EVESHAM
THROUGH TIME
Stan Brotherton

AMBERLEY

*To all members, both present and past, of the Vale of
Evesham Historical Society (VEHS) who have done so much to protect,
preserve, research and publicise the history of Evesham and its Vale.*

First published 2016

Amberley Publishing
The Hill, Stroud
Gloucestershire, GL5 4EP

www.amberley-books.com

Copyright © Stan Brotherton, 2016

The right of Stan Brotherton to be identified as the
Author of this work has been asserted in accordance
with the Copyrights, Designs and Patents Act 1988.

ISBN 978 1 4456 5817 9 (print)
ISBN 978 1 4456 5818 6 (ebook)

British Library Cataloguing in Publication Data.
A catalogue record for this book is available from
the British Library.

Typesetting by Amberley Publishing.
Printed in the UK.

Introduction

The picturesque market town of Evesham sits within a loop of the River Avon. At the heart of the town stood Evesham Abbey surrounded by the green open spaces of its demesne land. The modern town has mostly retained this wonderful ancient setting with parks, meadows and agricultural land extending from the Workman Bridge to the locally famous Hampton Ferry.

The earliest form of the town's name, 'Eoveshomme', denotes land in a river bend belonging to a man named Eof (that is, Eof's *homme*). The name recalls the Legend of Evesham, which recounts how the swineherd Eof saw a vision of the Virgin Mary. Awed and amazed by what he saw, Eof reported it to St Ecgwine (third bishop of Worcester) who, visiting the same spot, witnessed the same miraculous vision. Taking it as a divine sign, St Ecgwine founded an abbey here (consecrated 709). Before the abbey this area was 'an uncultivated spot, full of thorns and brambles'. Tantalisingly, William of Malmesbury (writing *c.* 1125) mentions an earlier, ancient church 'perhaps built by the British'. The town of Evesham, initially centred on Merstow Green and Vine Street, developed to serve the monastery.

From its earliest days the abbey was richly endowed with land and properties. Over time these estates became the 'Deanery of the Vale of Evesham', a monastic peculiar overseen by the Abbot which, at the time of the Dissolution of the Monasteries, comprised twelve parishes – St Lawrence and All Saints (Evesham), Bengeworth, Hampton, Badsey, Wickhamford, Offenham, North-and-Middle Littleton, South Littleton, Norton, Church Honeybourne and Bretforton.

The town of Evesham became the central market and port serving the surrounding estates. The land, carefully managed and cultivated, became a source of significant local prosperity. In 1585 William Camden considered the Vale 'well deserved to be called the Granary of All these Counties, so good and plentiful is the grounds in yeeldinge the best corne abundantly'. In 1612 Michael Drayton declaimed 'Abounding in excess the Vale of Evesham lies'. Evesham has long been famous for its produce; market gardening was undertaken here as early as 1685. Writing in 1794 William

Tindal observed that 'gardening is the sole manufacture of this place ... [occupying] the whole of the abbey site and to form a circle of considerable dimensions almost around the whole town'.

The importance of horticulture was accelerated by the coming of the railways in 1852, linking Evesham to distant markets including Birmingham, Covent Garden and Glasgow. John Idiens remarked that 'We have an almost perfect train service to every part of the Kingdom.' This growth was sustained by local allied trades and the security of tenure afforded by the Evesham Custom. In 1870 market garden land comprised some 1,000 acres, but by 1900 it was 10,000 acres.

In 1820 came the first stirrings of modern tourism with a short brochure entitled *Rambles in the Vicinity of Evesham*. Joseph Bently (1840) reported that

The situation of the town is peculiarly eligible and pleasant ... the shops are furnished with every necessity and luxury so that Evesham is equal to most places in those constituents of comfort and civilization; while its surpassing beauty, and healthy atmosphere, present strong attractions to visitants, who will find excellent society here.

Herbert New in *A Day at Evesham* (1873) wrote

The streets of Evesham are regular and generally well-built. Bridge Street is almost as picturesque as an old Flemish street ... No tall chimneys rise above the houses to impair or contrast with the elegant forms of the Bell Tower, its companion spires of All Saints and St. Lawrence, or the bright new spire of Bengeworth.

The population of the town was around 2,000 in 1701, around 3,000 in 1801, a touch over 7,000 in 1901, and exceeded 22,000 in 2001. As the town flourished new homes were built, especially in the Bewdley, the Rynal, down Common Road, on Greenhill, and all around Bengeworth and Hampton. Large estates have been constructed including Fairfield and Four Pools, with new developments built off the roads leading to Pershore, Cheltenham, Badsey, Offenham and Broadway.

This book is loosely organised as a meandering walk which starts in Abbey Park (by the Bell Tower) and wends its way, with some backtracks, to finish in Hampton (by the church). The images have been selected to illustrate the town's varied history and include mills, factories, fields, farms, shops, inns and churches.

Evesham is a fascinating market town well worth a visit, with deep sacred roots and a rich history of growing and gardening.

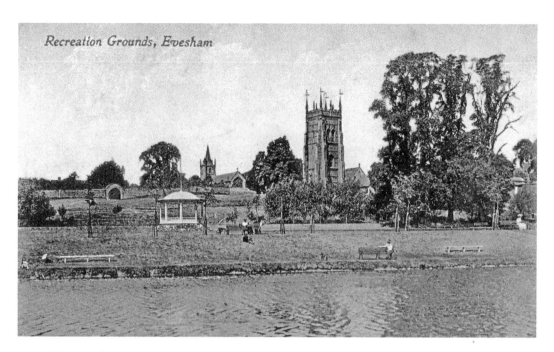

Recreation Grounds, Evesham

Abbey Park, 1920 and 2016

Evesham's iconic Bell Tower, standing some 110 feet tall, dominates this ancient market town. It was built *c.* 1524 to *c.* 1532 by Abbot Clement Lichfield. The Bell Tower holds fourteen modern bells, all cast by Taylors of Loughborough, and is considered one of the finest peals in the kingdom. In 2014 a major local appeal raised £500,000 for urgent conservation. This work, which started in April 2015, involved wrapping the Bell Tower from plinth to pinnacle in scaffolding.

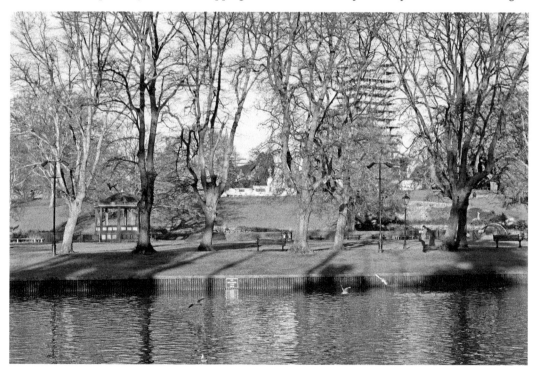

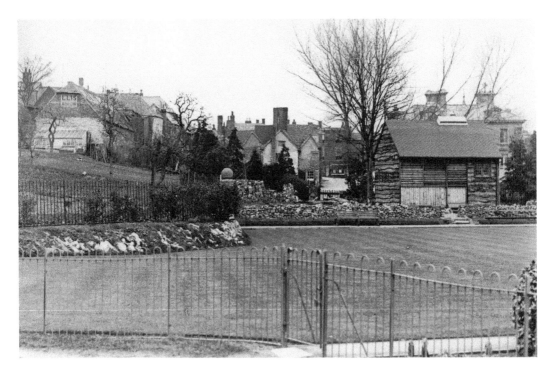

Bowling Green and Fishponds, 1930 and 2015

The older view shows a corner of Abbey Park looking north from the Bowling Green towards the back of the old Fleece Inn. The modern view has a longer perspective which includes an ornamental pool. The original pools were built by the abbey for keeping fish. The first (oldest?) pool, now filled in, was next to St Egwin's Fountain. The second and third, constructed by Abbot Ralph (1214–29), are now a paved area and a lily pond.

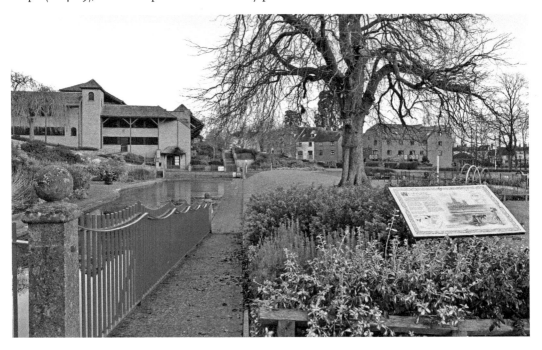

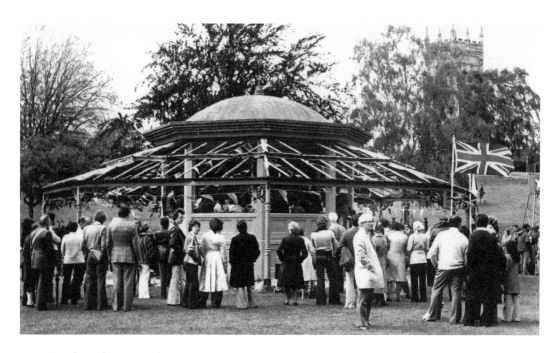

Bandstand, 1977 and 2015

Abbey Park is owned by the Rudge Estate and rented on a ninety-nine-year lease by Wychavon District Council (expiring 2045). The site of the War Memorial was gifted by the Rudge family to the Town Council. This area, now dedicated to leisure and entertainment, includes children's play areas, winding paths, ornamental planting and a bandstand. The bandstand, erected in Lower Abbey Park in the 1920s, once supplemented another bandstand in the Workman Gardens (removed in the 1960s).

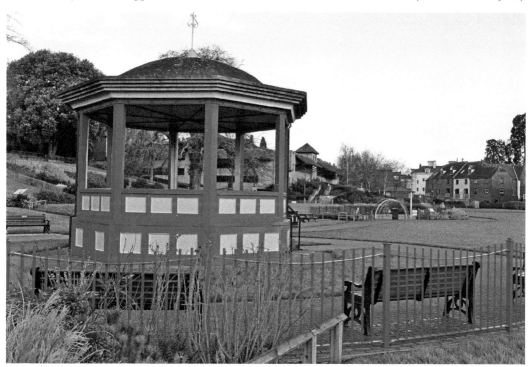

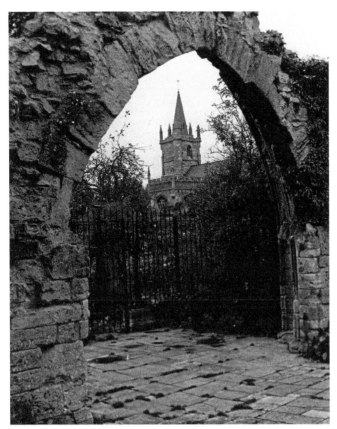

St Lawrence Seen Through the Cloister Arch, 1950 and 2015

The cloister arch marks the doorway from the abbey cloisters into the chapter house (built between 1296 and 1318), a high ten-sided room some 52 feet in diameter with tall windows, a stone vault, gilded bosses and no central column. Here, each day, the monks read a chapter from *The Rule of St Benedict*. Little now remains. William Petre, writing to Thomas Cromwell on the Dissolution of Evesham Abbey, said it surrendered with 'as much quietness as might be desired'.

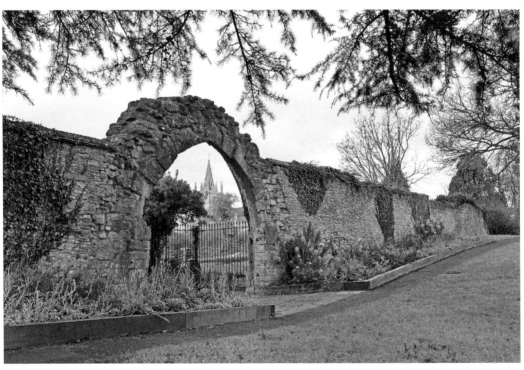

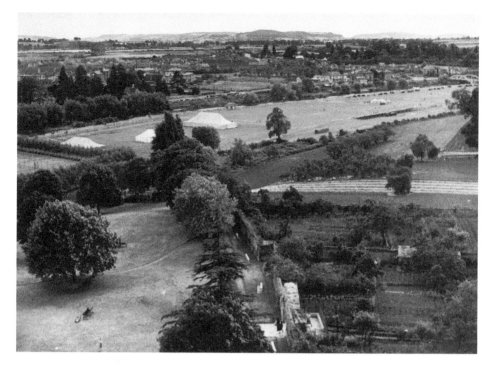

View from the Bell Tower (South-east) Overlooking Abbey Site and Meadows

The Evesham monk John of Alcester recorded the abbey's surrender: 'In the year of our Lord 1539 [1540 in the modern calendar] the monastery of Evesham was suppressed by King Henry VIII, in the 31st year of his reign, the 30th day of January, at evensong time, the monks being in the choir at this verse "Deposuit potentes" ['He has scattered the proud' from the *Magnificat* or *Song of Mary*], and would not suffer them to make an end.'

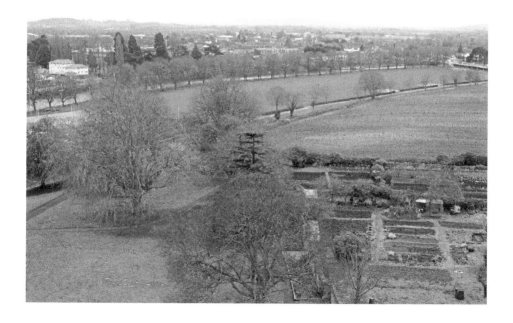

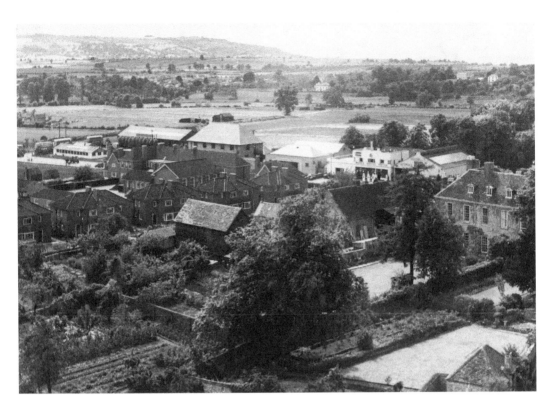

View from the Bell Tower (South-west) Overlooking Abbey Road

The 1950s view shows part of the abbey site, Abbey Gate, the police houses (long since sold for private use) and the old magistrates' court and police station. Moving south along Abbey Road are the workshops of H. Robbins (automobile engineers), the Morris Service Station, the telephone exchange (1935) and around the corner the bus depot. The modern view (2015) shows the Evesham Leisure Centre (officially opened in 2010) and the dramatic growth of Hampton.

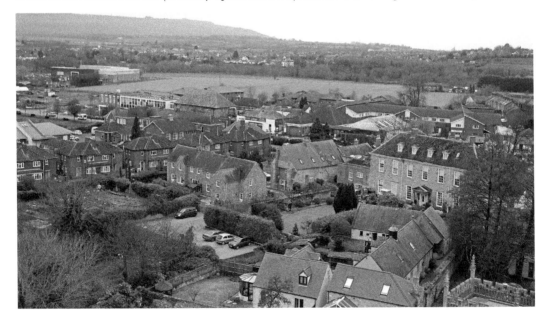

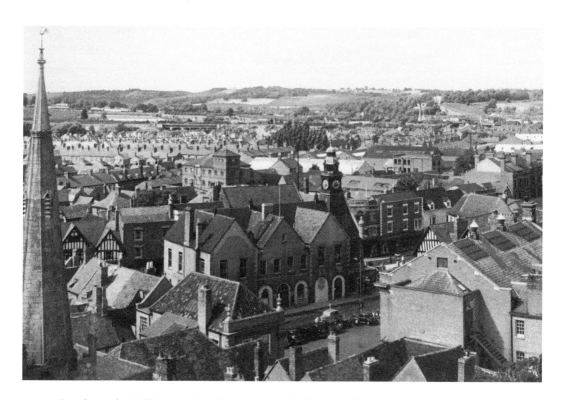

View from the Bell Tower (North-west) Overlooking Market Square *c.* 1950 and 2015

These two views of the Market Square show that, superficially, little has changed. Obvious differences include the pedestrianisation of the square and the addition of a fourth gable to the Town Hall. A closer look reveals significantly fewer chimneys in the modern photograph. It is also possible to make out changes in the Bewdley, including Bewdley Court retirement flats and a new car park.

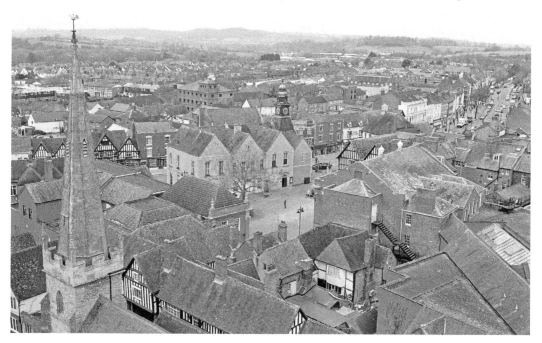

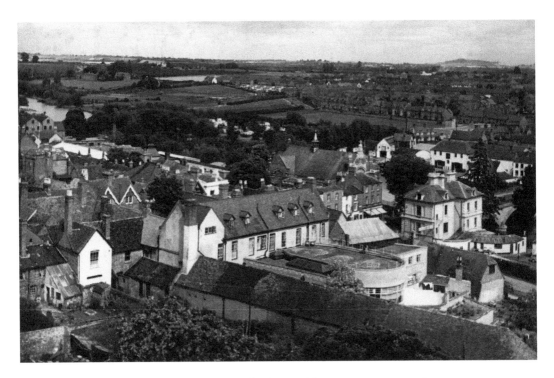

View from the Bell Tower (North-east) Overlooking Bridge Street *c.* 1950 and 2015

Significant developments have occurred in Bengeworth since the 1950s, as revealed by a comparison of these pictures. In the 1950s there were few buildings between Burford Road and the river. The factory behind the Methodist church has now become slate-roofed houses. The modern picture also shows 'The Orchards' housing development (off the Offenham Road), currently under construction (2016), rather than the previous orchards.

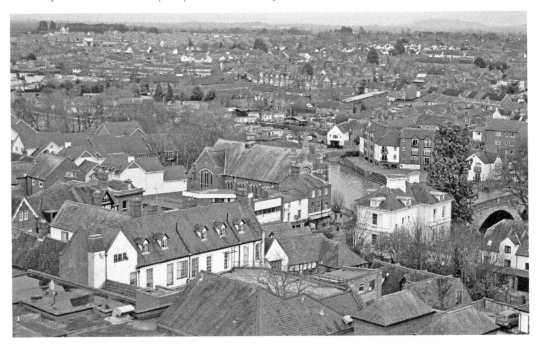

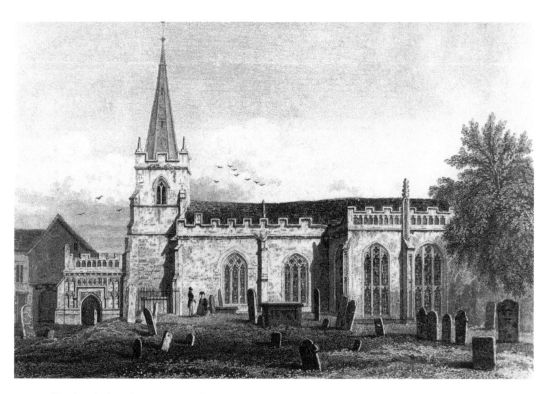

All Saints' Church, *c.* **1820 and 2015**

All Saints was built in the late twelfth century to serve the eastern half of the growing medieval town. The west porch and south chapel were both added 1500–13. Abbot Clement Lichfield lies buried in this chapel. From 1873–76 the church was extensively remodelled on Ecclesiological principles by Frederick Preedy for the Revd F. W. Holland (vicar 1872–81). The churchyard was cleared of gravestones in the early 1970s, when statutory responsibility for its maintenance was transferred to Evesham Town Council.

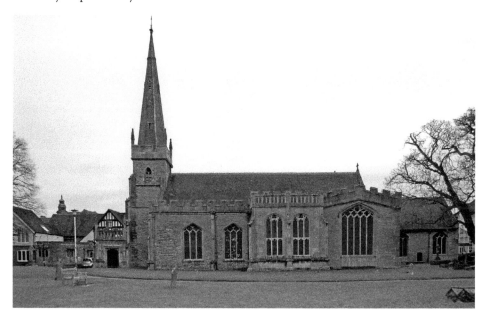

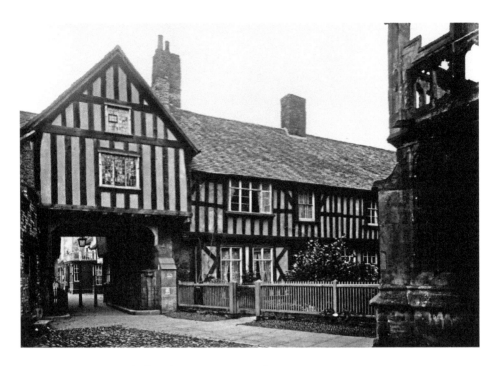

Norman Gateway and Church House, 1900 and 2015

The newly elected Abbot of Evesham was received by his monks at the Norman Gateway (built for Abbot Reynold Foliot, sometimes known as Reginald, 1139–43) before being conducted to the abbey church for installation. The neighbouring fifteenth-century timber-framed building served as the vicarage of All Saints until 1874 when a new one was built on Merstow Green. The vicarage house of St Lawrence, on Merstow Green, was demolished in the period 1642–60. From *c*. 1660 the same vicar served both parish churches.

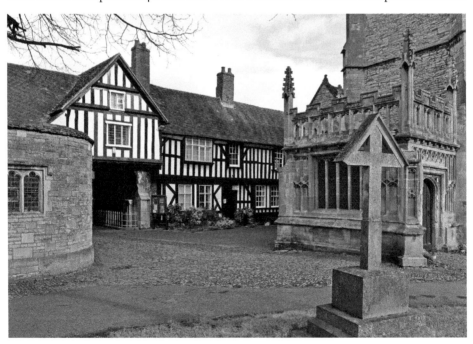

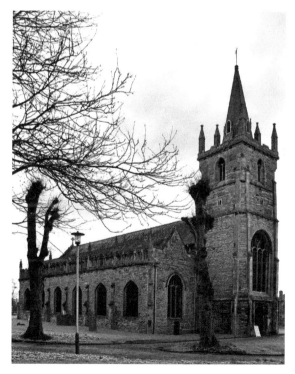

St Lawrence's Church, 1900 and 2015
St Lawrence, first mentioned in 1195, was reconsecrated in 1295 after being desecrated during the Battle of Evesham (4 August 1265). Ambitious roof repairs were undertaken *c.* 1737 but soon afterwards the roof collapsed; the church stood roofless and largely unusable for nearly a century. In 1800 the Diocesan Surveyor described it as 'a disagreeable, unseemly object and totally useless'. It was extensively restored in 1836–37 by Harvey Eginton. Declared redundant in 1978 the church is now managed by the Churches Conservation Trust.

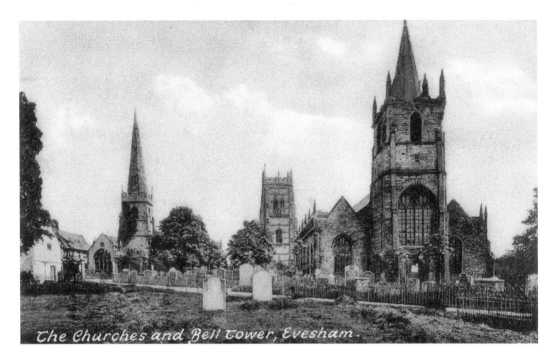

The Churches and Bell Tower, Evesham.

Churches, *c*. 1880 and 2015

The 'Harrowing of the North' (1069–70) by William the Conqueror forced a large number of people to seek refuge in the south. The houses, streets and churchyards of Evesham were said to be crowded with these refugees, many of whom received help and hospitality from Abbot Aethelwig. The West Midlands did not suffer under the Norman Conquest; indeed Abbot Aethelwig was one of the few Englishmen trusted by the new king.

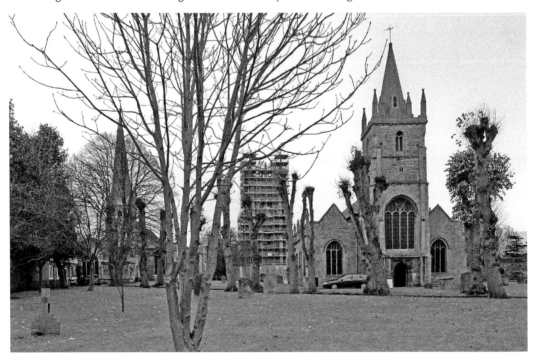

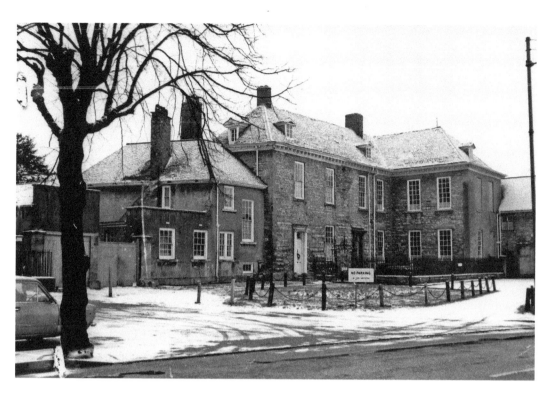

Abbey Gate, 1950 and 2015

On this site stood the abbey's great gateway which Habington (1640) said was 'as large and as stately as any at this time in England'. The gateway was adorned with battlements and decorated in front with numerous statues of saints and royal benefactors. The gateway was replaced *c.* 1711 by the current Georgian house (the garden extended to the Cloister Arch). The building later became the offices of the building firm of W. A. Cox, and in 2009 was converted into apartments.

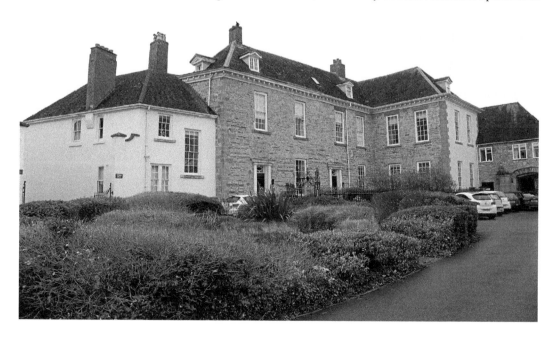

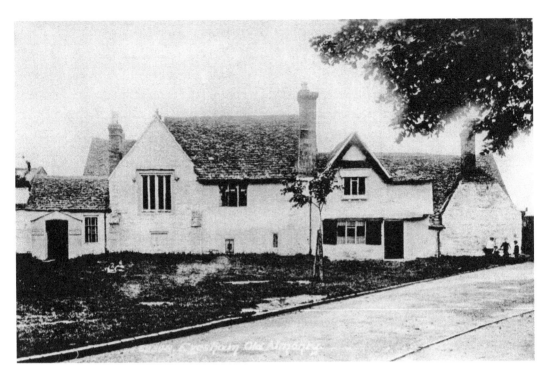

Almonry, *c.* 1880 and 2014

This complex building originally housed the abbey almoner who helped the local sick and poor. After the Dissolution of the Monasteries it became a residence of Abbot Philip Hawford (who surrendered the abbey), later becoming tenements and commercial offices. In 1957 the building, now owned by Evesham Town Council, was opened as the Almonry Museum by members of the Vale of Evesham Historical Society (founded 1950) who installed their own collections. Generous donations and loans have significantly enlarged and enriched the collections.

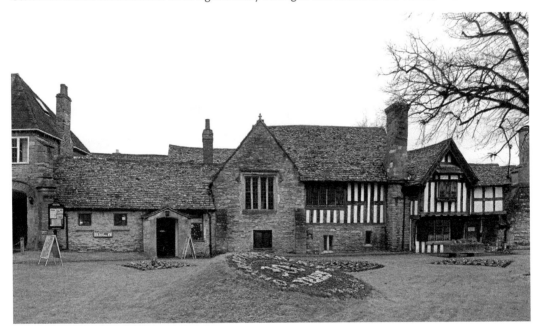

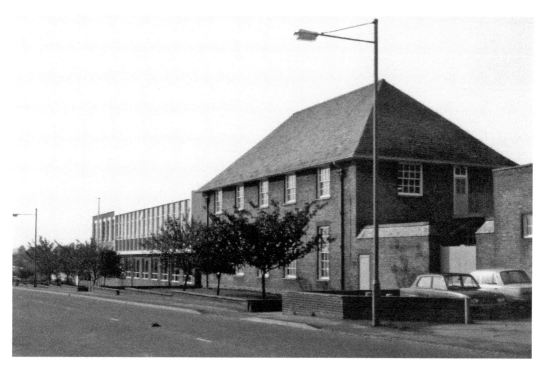

Telephone Exchange, Abbey Road, *c.* 1975 and 2015

From 1890 Evesham enjoyed telephone communications; indeed, Evesham was the second place in the UK to have subscriber trunk dialling (STD) because market gardeners needed to book long distance calls to remote markets such as Birmingham, Bristol, Glasgow and Covent Garden. The current telephone exchange building dates from 1935, with a modern extension built in 1958. Mobile phones, automated exchanges and improved communications have made these buildings somewhat redundant.

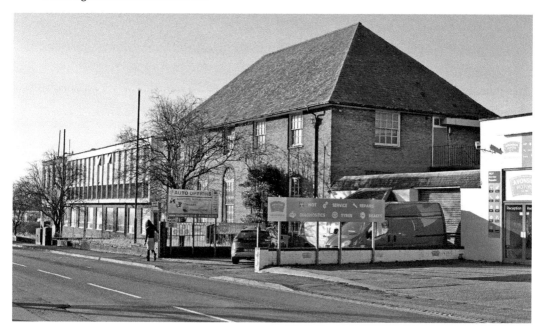

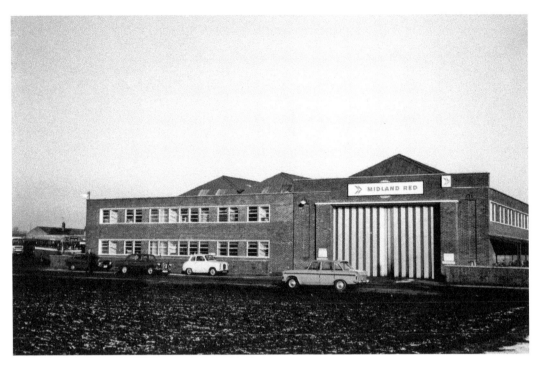

Midland Red Bus Depot, Abbey Lane, *c*. 1965 and 2015
In 1931 the Birmingham and Midland Motor Omnibus Co. Ltd opened a single-bay, steel-framed, corrugated-iron bus depot in Abbey Road. During the Second World War the buses were converted to producer-gas, the depot being enlarged for trailers and a coaling station. The depot was modernised in 1957 with a new brick frontage and offices. In 1979 it was split with the eastern half operated by Quinney's Dairy. The site was sold in 2004 and the building demolished in 2007.

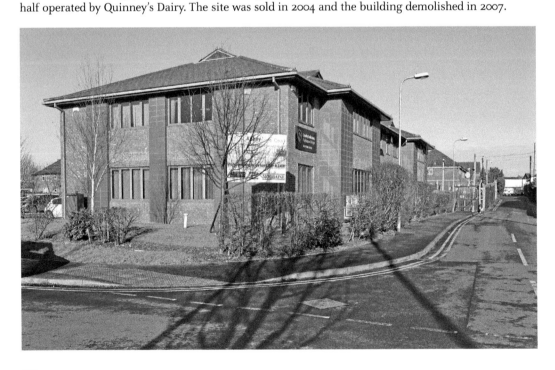

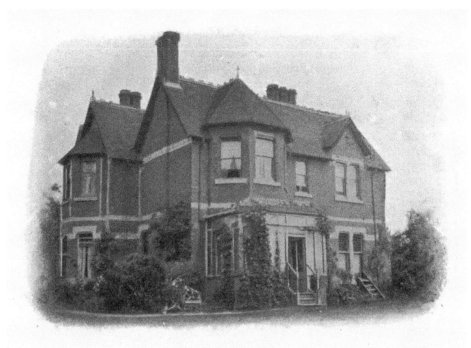

Evesham Vicarage.

Evesham Vicarage, Merstow Green, 1909 and 2015

A new vicarage, built on Merstow Green in 1874, was demolished in 1968. A new health centre was built on the site *c.* 1977 (since demolished and replaced by a new health centre). Merstow Green was an open green space until the 1970s when it became a car park. Nicholas Pevsner, writing in 1968, wrote that '... Vine Street continues in Merstow Green, a true green, also with trees. This is an asset Evesham must retain and cultivate. Car parking has already reduced its amenity considerably.'

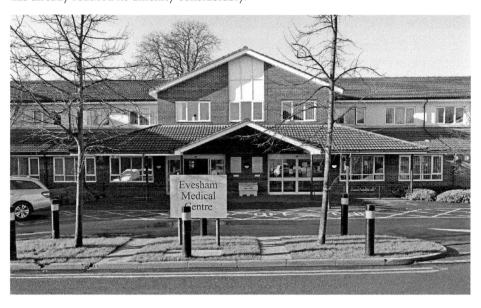

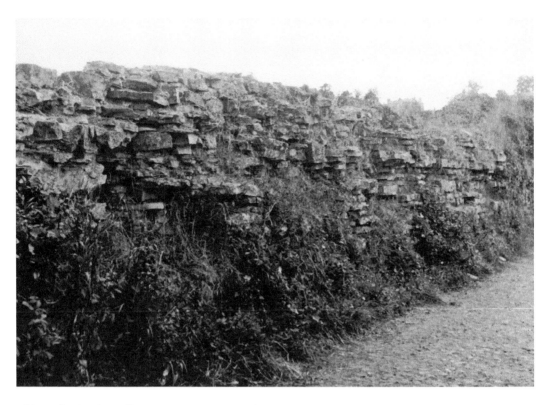

Abbot Cheriton's Wall, Boat Lane, *c.* **1950 and 2015**
Boat Lane leads from Merstow Green to the Hampton Ferry. The south of this lane marks the line of a wall built between 1316 and 1336 by Abbot William of Cheriton to separate the abbey's demesne land from the town. This wall, thought to have been some 10 feet high and 3 feet thick, ran westward from the west wall of the Amonry to the river. Some fragments of the wall remain.

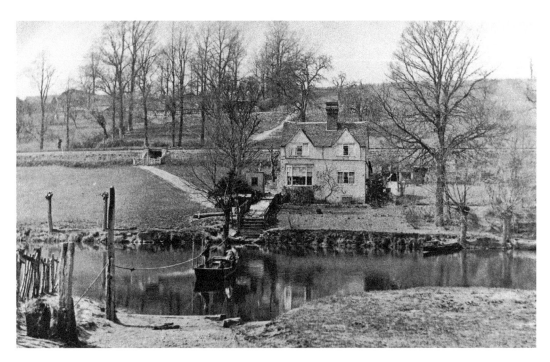

Hampton Ferry, 'Evesham's Natural Beauty Spot', *c.* 1920 and 2015

The ferry is one of the oldest rope-pulled ferries in England, linking the town within the peninsula to nearby Hampton. In 1929 Ernie and Eileen Huxley moved here. Ernie was a keen angler who spent as much time as he could fishing; he organised an increasingly popular annual angling competition. Eileen opened a café to serve breakfasts to the anglers, with sausage and bacon sandwiches a particular favourite.

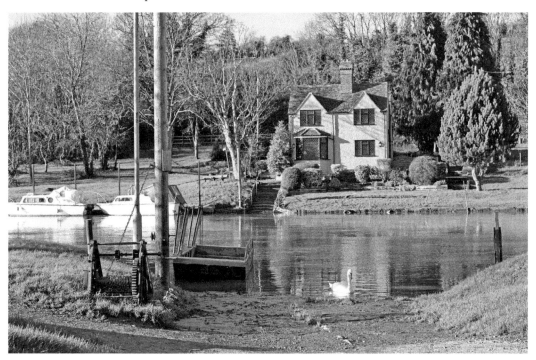

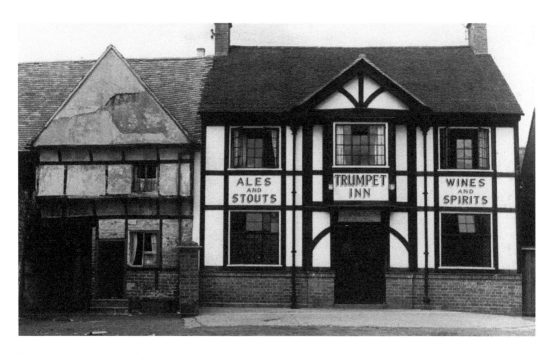

Trumpet Inn, 1952 and 2008

The original medieval Trumpet Inn was demolished in the 1930s and replaced by a mock-Tudor building. The inn sign is likely to be a religious one (an angel's trumpet) with the inn serving visitors and pilgrims. In the 1800s the inn hosted the 'Trumpet Club' – a friendly society that did good works among the local market gardeners. The building immediately west of the Trumpet is a medieval house; a fascinating contrast between an original and a recreated medieval house.

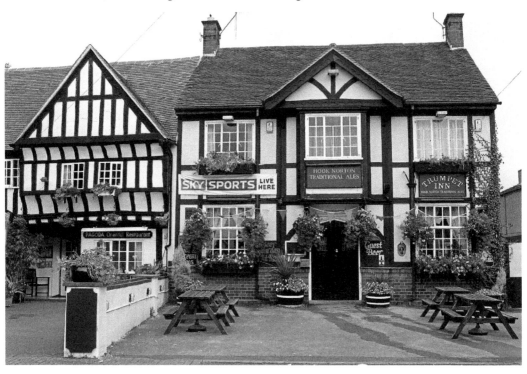

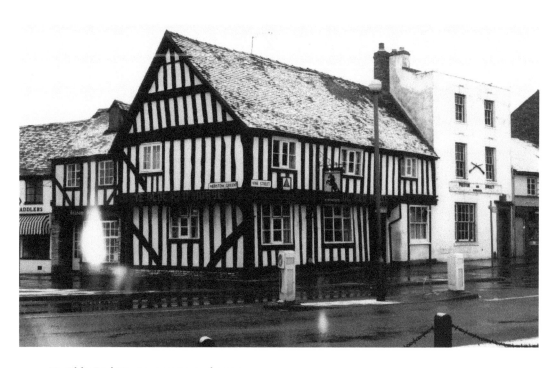

Ye Olde Red Horse, *c.* 1950 and 2015

The sign of the Red Horse is very rare, deriving from the Old English roan or red horse now long since extinct. Evesham once hosted famous horse fairs near the Town Hall ('Swan Lane' was once known as 'Horse Lane'). Mr Sharpe in his witty *Song of Signs* (1810) said 'Red Horse is a sign I know naught what to say! For a red horse I ne'er saw, by night or day!'

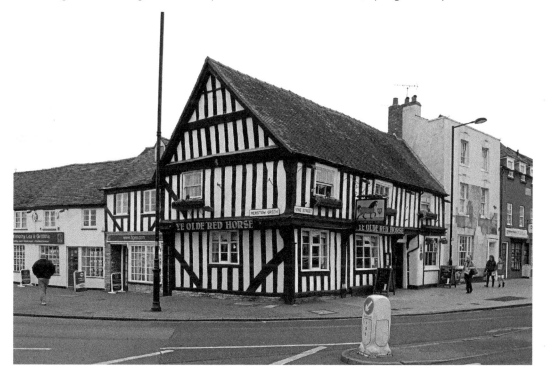

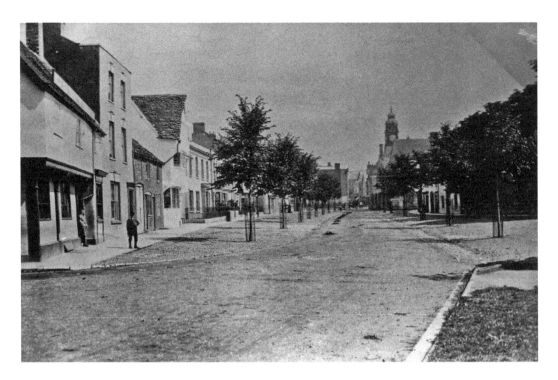

Vine Street, *c.* 1900 and 2015

Before 1840 this street was known as Pigmarket, and sometimes as Swine Street, from the pig pens erected on market days. The modern name appears to be a genteel Victorian refinement, perhaps inspired by the Domesday Book mention of newly planted vineyards on Clarke's Hill. Vine Street and High Street were built very wide to accommodate grain and livestock trading, with narrow entrances to control entry and to facilitate the collection of tolls and taxes.

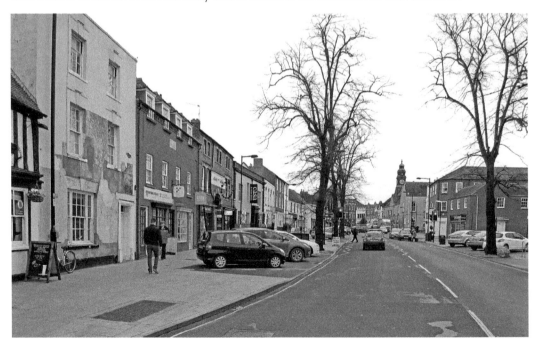

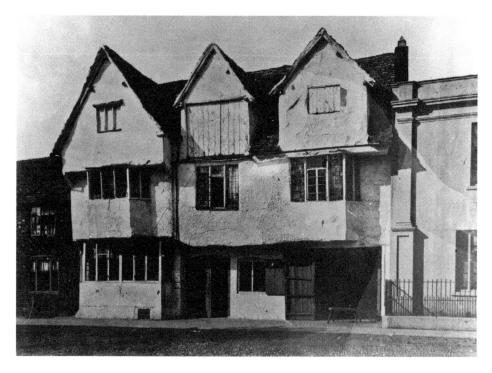

White's House, Vine Street, *c.* 1900 and 2015

A large medieval merchant's house once stood a few doors down from Ye Olde Red Horse. This was replaced in the 1920s by a new building with a central passage leading through to a yard and stabling. In the 1980s this was transformed into Vine Mews, a collection of small specialist shops and a welcoming café. The shopping arcades of Vine Mews and Vine Court link Vine Street with the Brewery car park, once the site of Williams' brewery (later Rowland's).

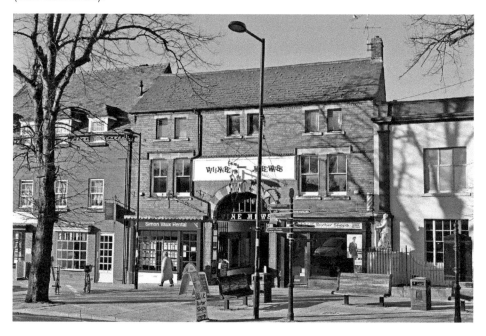

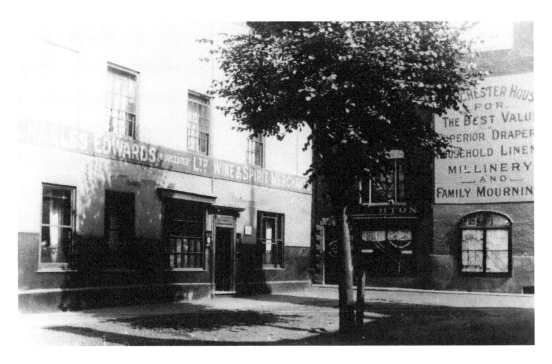

Corner by the Town Hall, *c.* 1880 and 2015

At the junction of Vine Street and High Street is a narrow alley, previously known as 'Genesis Lane', leading to the Bewdley. The building south of this junction was 'The Farrier's Arms', renamed in the 1920s as 'The King Charles'. This was the headquarters of the Evesham Old Contemptibles' Association. On the corner sits Manchester House with a square frontage jutting into the road. This was later rounded to smooth the flow of traffic.

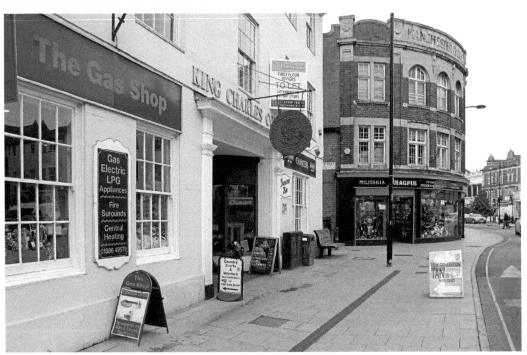

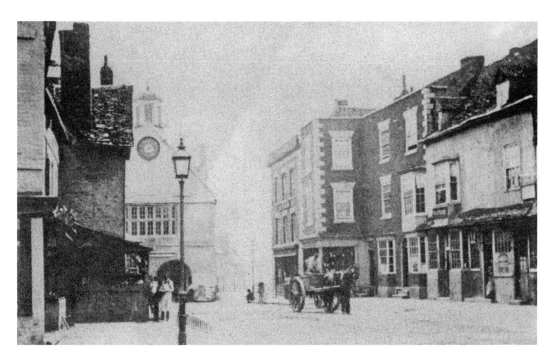

Southern End of High Street, *c.* 1880 and 2016

A detailed comparison of these two images reveals many striking differences. In the old picture there is a clock mounted in the apex of the end wall and a small but simple turret. In the new photograph an engraving sits beneath the apex ('VR AD 1887') while a new clock sits inside an ornate cupola. The new clock, installed to celebrate Queen Victoria's Golden Jubilee, was known as 'Old Emma' or 'Emma Morris' after the wife of the mayor Isaac Morris.

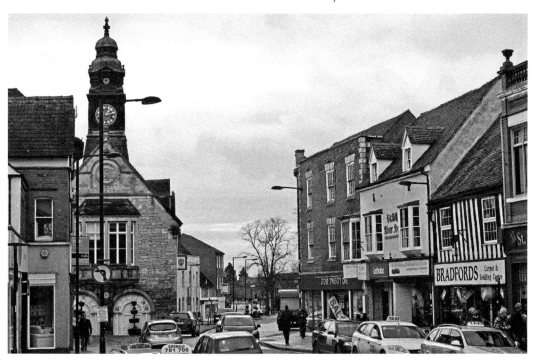

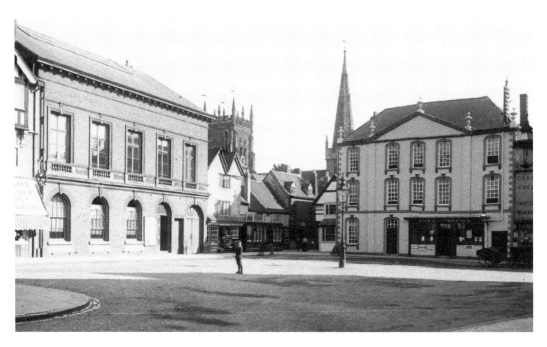

Market Place, *c.* 1900 and 2015

From 1883 to 1960 the Post Office (rebuilt in 1926) stood on the south side of the Market Place. To the east was The Farmers' and Merchants' Hall, later enlarged as the Public Hall (with library). This is now an entrance to the Riverside Shopping Centre (opened 1989). A market cross once stood in the centre of the Market Place (removed *c.* 1760). The square was pedestrianised in the late 1980s. The discretely placed K6 telephone kiosk (*c.* 1960) is listed.

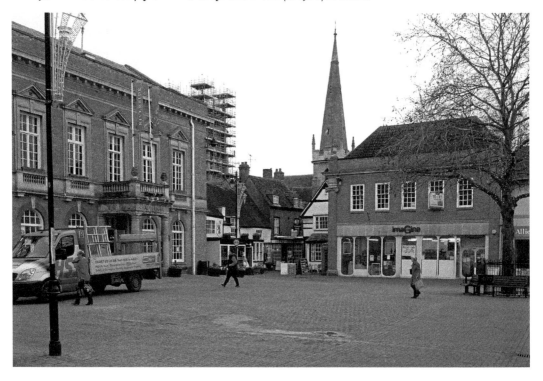

Red Lion and Half-timbered Walker Hall, *c.* **1900 and 2008**
The south-east corner of the Market Square holds a fascinating assembly of ancient buildings. The Walker Hall is named after the Revd Walker (vicar of Evesham 1900–19) who helped fund its preservation, but bears the monogram of Thomas Newbold (abbot 1491–1514) in the apex of its north elevation. Revd Walker's sermons were apparently rather lengthy and members of the choir would, when the vicar began to preach, leave quietly by the vestry door to visit the nearby Red Lion.

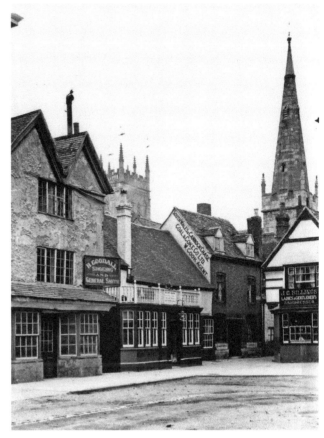

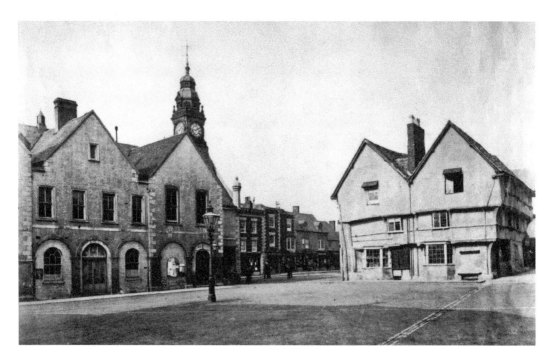

Town Hall, *c.* 1900 and 2015

The Town Hall was built *c.* 1580 by Sir Philip Hoby who, in 1541 and 1542, purchased the greater portion of Evesham Abbey's estates from the Crown. The original building had two storeys with an open arcade below and a large room above. The arcade served as threshing floor and market; the southern section later became (*c.* 1790 to 1835) the borough gaol and gaoler's residence. The ground floor later became a fire station – the engines exited and returned via Vine Street.

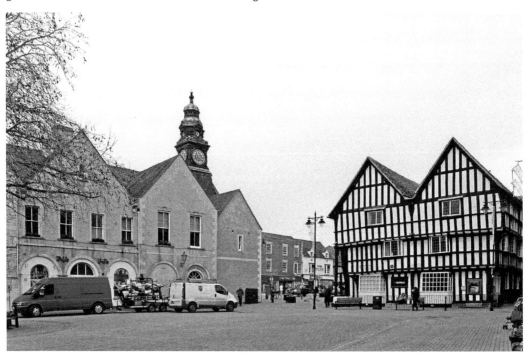

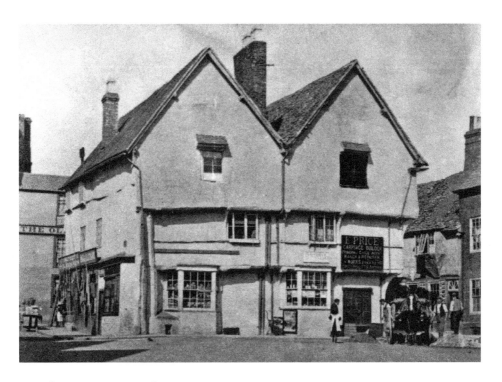

Round House, *c.* 1880 and 2015

Previously known as Booth Hall this merchant's house encroaches on the market square. From *c.* 1580 to *c.* 1770 it was a hostelry, then shops, and is now the NatWest Bank. The parish boundary between All Saints and St Lawrence runs down the eastern side of the High Street, through the Alley, takes a square-shaped detour to incorporate the Round House into the parish of All Saints, through the Norman Gateway, between the churches, under the Bell Tower, and by stages down to the river.

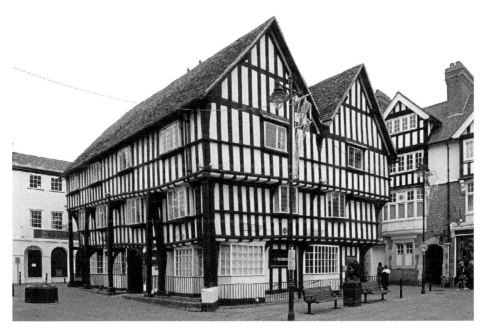

Bewdley Street, c. 1950 and 2015

The name 'Bewdley' comes from the French *beau lieu*, meaning 'beautiful place'. The so-called 'mayor of Bewdley Street' was elected annually on the Wednesday of Whit Week. A mayoral candidate was escorted to the George & Dragon to celebrate, then afterwards mounted on a cart to proceed up and down the street. If he was 'accidentally' upset into a ditch, then another candidate was selected and tested. This custom stopped after 1850 following a particularly uproarious celebration.

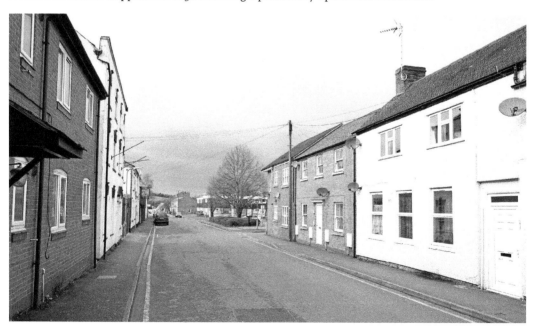

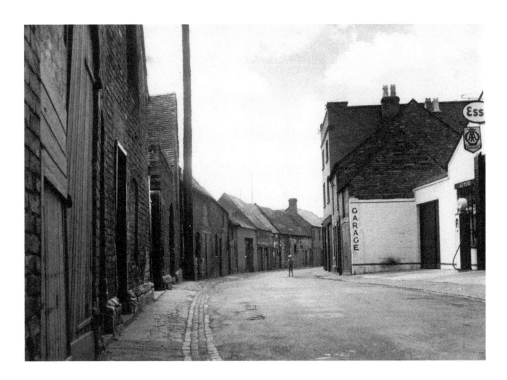

Brick-kiln Street, *c*. 1950 and 2016

The name 'brick-kiln' suggests there were kilns here for firing bricks for local building. However, there were no such kilns in Brick-kiln Street, although in the mid-eighteenth century there were six hop kilns. The earliest name of the street is Britain Street, which slipped to Bricken, and finally, perhaps following confusion over kilns, became Brick-kiln. This street may also have been known as 'Le Comon Backhouse' as it provides common access to the substantial properties fronting on High Street.

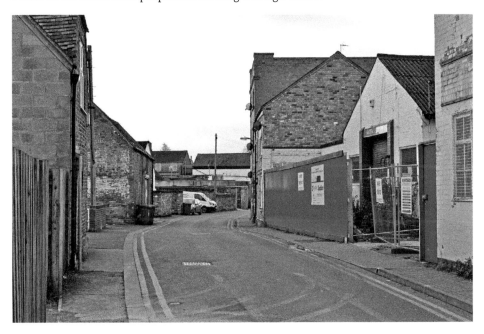

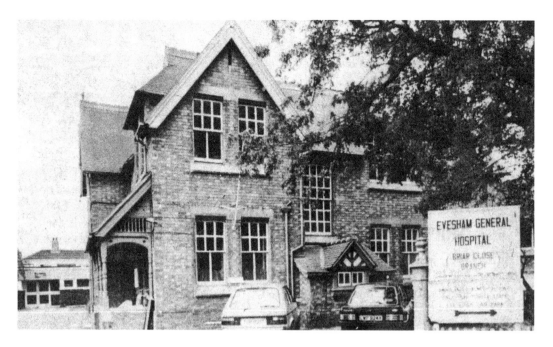

Evesham Hospital, Briar Close, *c.* 1985 and 2015

The word 'briar' previously denoted any wild rose (not just eglantine). The name was attached to a specific parcel of land, then later to the road running through it. The Evesham Cottage Hospital, built here in 1879, was enlarged in 1893, renamed in 1948 as Evesham Hospital, and closed in 1988. Some buildings were demolished for redevelopment and others were converted into flats. A temporary RAF hospital (1942–1945), built behind the workhouse, was later incorporated into the Avonside hospital (known by some as 'the Grubber').

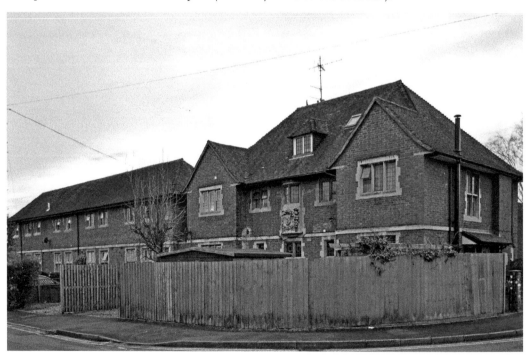

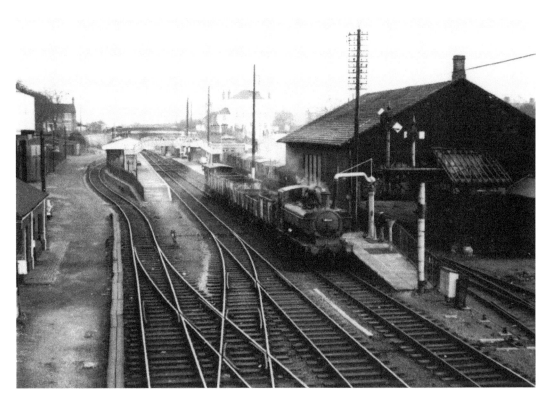

GWR Station, *c.* 1965 and 2016

In 1852 the Oxford, Worcester & Wolverhampton Railway (later absorbed by GWR) came to Evesham. In 1864 the Midland Railway (later incorporated into the LMS) arrived. The Midland station was closed in 1964 and later converted into offices (now cheekily known as 'The Signal House').The Midland goods yard was closed and developed as the Shepherd's Pool housing estate. The bridges connecting Briar Close to the Worcester Road were known, from the filthy smoke from steam engines, as Black Bridges.

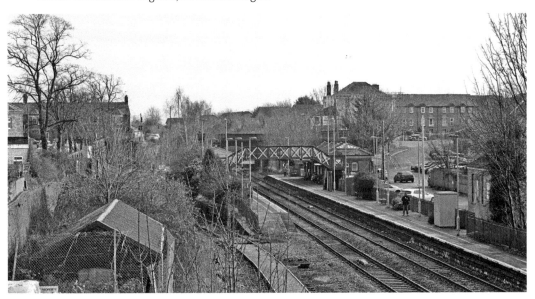

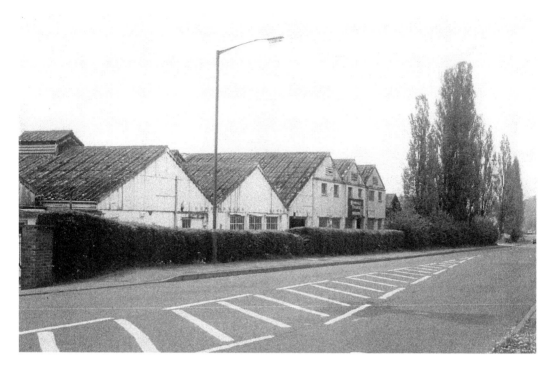

Worcester Road, *c.* 1970 and 2016

On the site now occupied by Tesco, Samuel Wallace Smedley (1876–1958) established a small factory, later replacing it with a larger purpose-built factory. Adopting American methods, he pioneered canning in the UK. From 1937 his firm also processed frozen foods. In 1946 he kindly gifted 'Wallace House' to the town (formerly the site of the police station) for organisations 'having athletic, social or educational objects mainly for the benefit of the young'. The Smedley plant in Evesham closed in 1973.

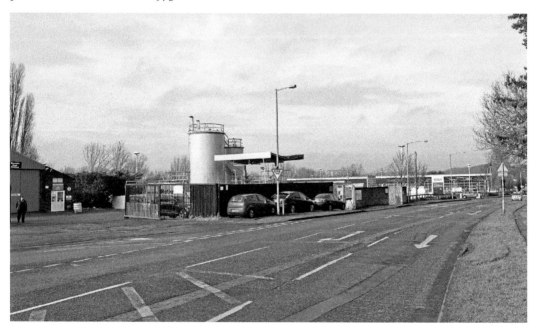

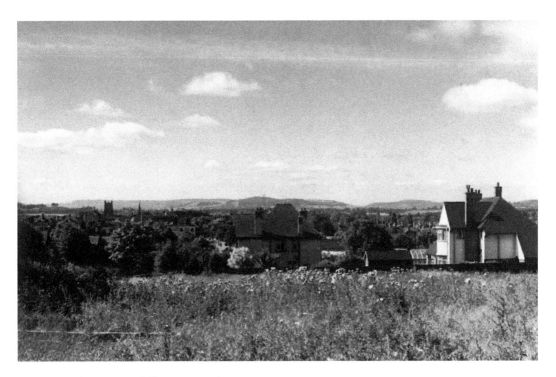

View from Greenhill, *c.* 1950 and 2016

The Battlewell, near the toll gate house, marks the site where Simon de Montfort (sometimes called the 'Father of Parliament') was slain in the Battle of Evesham. This event was described by Robert of Gloucester (*c.* 1270) as 'the murder of Evesham for battle it was none' from the brutality of the royal army. A different view of royalty is celebrated in the Victorian housing at the bottom of Green Hill with names such as Victoria Avenue, Windsor Road and Cambria Road.

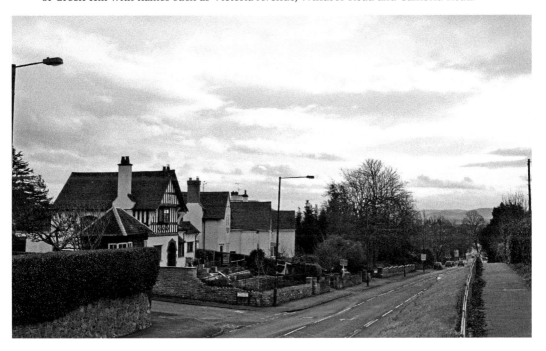

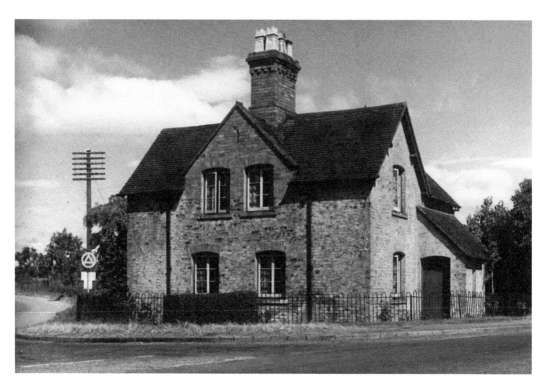

The Battlewell Toll House, *c.* 1950 and 2015

From 1706 turnpike trusts helped raise money from tolls to fund necessary road repairs. The Vale of Evesham Road Club (formed in 1792) described the roads in the Vale as 'founderous and unsafe for travelling'. In 1813 William Pitt wrote of Worcestershire that 'The principal roads from town to town, being supported by toll gates, are generally kept in good repair ... The toll gates in Worcestershire, however, are neither numerous nor extravagant in their tolls.'

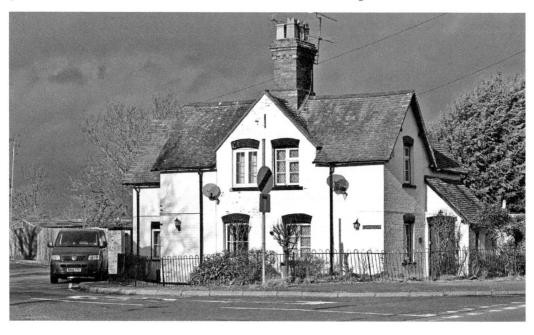

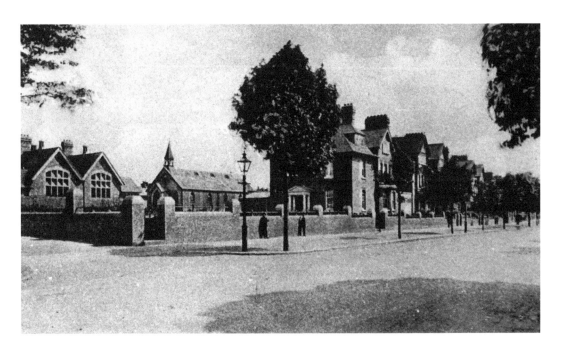

Roman Catholic Church, High Street, *c.* 1900 and 2015

The Roman Catholic parish of St Mary, Evesham, was founded in 1887 and for its first ten years was served by priests from Broadway. In 1897 Father Robert Patten was appointed Parish Priest, using a temporary corrugated-iron building in Magpie Lane (now Avon Street). In 1907 this building hosted the civic wedding of Princess Louise d'Orleans and Prince Charles de Bourbon (the celebrations took place at Woodnorton Hall). The foundation stone for the new church was laid in 1911; it was built by Sebastian Pugin Powell and opened in 1912.

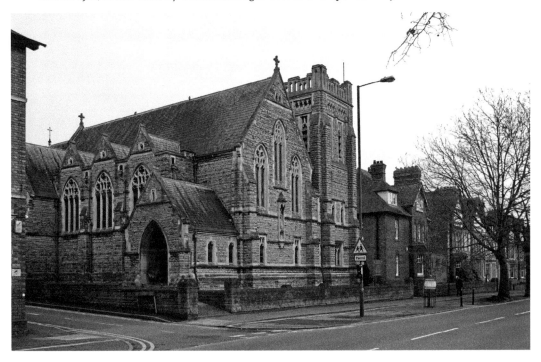

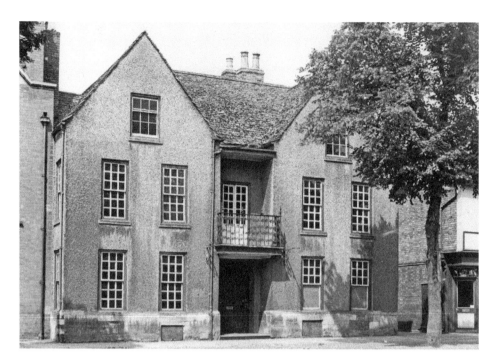

Almswood House, High Street, _c._ 1950 and 2015
In 1539 the upper part of High Street was called Allmyswood or Almen Wood, a name later adopted by this large seventeenth-century house. This name shows that woodland once stood very close to the town. According to D. C. Cox (2015), in the early tenth century the abbey had an enviable landed estate with nearly 10,000 acres of productive land south of the Avon and some 5,000 acres on its own side, where most of the landscape was wooded.

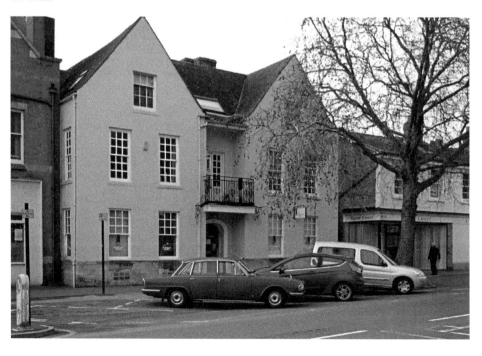

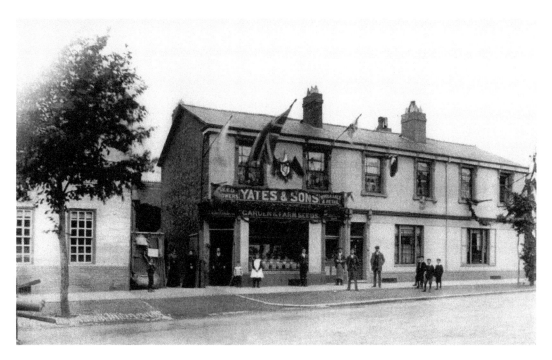

Yates, High Street, *c.* 1950 and 2015

For much of the twentieth century seed merchants thrived in Evesham, including Harrisons in Waterside, G. A. Bunting and Speed Seeds, both in Port Street, A. H. Wright in Vine Street, and Yates in High Street. The decline of local horticulture meant that these shops inevitably had to close. In 1998 the site of Yates was developed into retirement accommodation. An extension to Yates Court, completed in 2015, created new retirement apartments on the site of the Central Market (closed in 2007).

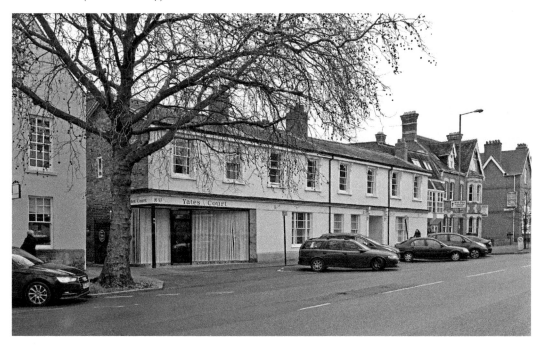

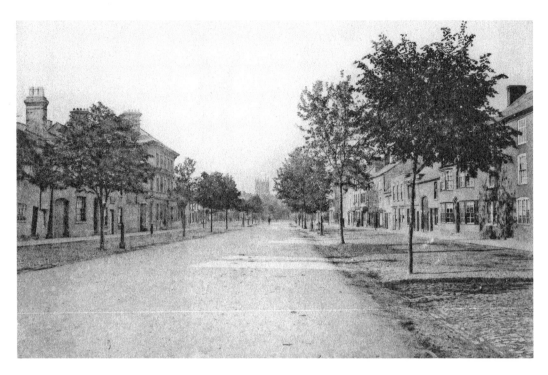

High Street Looking South to Bell Tower, *c.* 1880 and 2015

The High Street has been called the widest High Street in the county; its width reflects its use for cattle and sheep markets. A line of walnut trees was planted *c.* 1810 from the middle of High Street to the top of Greenhill. These trees were to provide wood for gun stocks in preparation for resistance against Napoleon Bonaparte and his 'Army of England'. In the 1930s some of these trees still stood in the grounds of The Lodge, Greenhill.

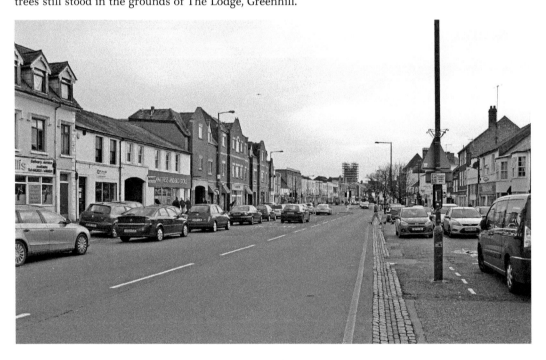

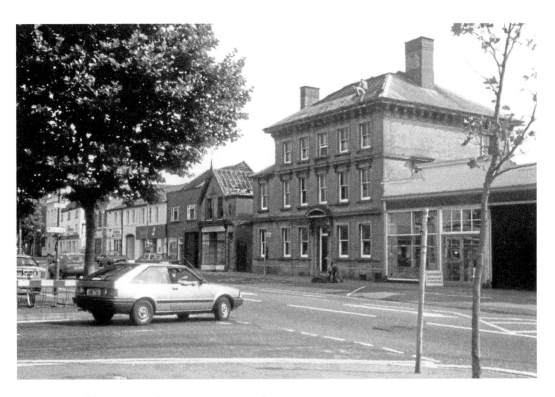

Cotswold House, High Street, *c.* 1970 and 2015

The company of H. Goodall, founded in 1898 by Harry Goodall, started as a blacksmith and coachbuilding business in Market Place but soon moved to Vine Street to work on horse-drawn traps and drays. In 1923 the business moved to High Street to focus on motor vehicles. In the early 1990s the business moved to the bottom of Green Hill, and Cotswold House was demolished to create new offices and a supermarket.

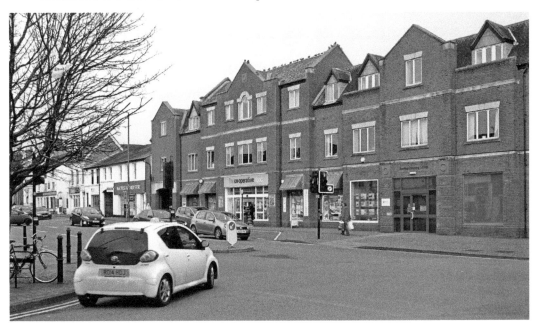

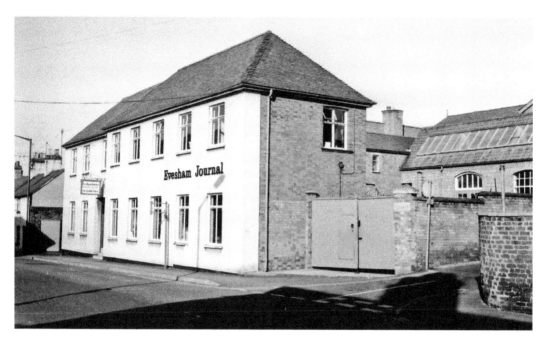

Journal Press, Swan Lane, *c.* 1960 and 2015

Until the 1720s this lane was known as 'Horse Lane' from the horse fairs held here. The modern name derives from 'The Swan', though in 1845, when that inn briefly became a private residence, the lane was known as 'Cross Keys Lane'. The *Evesham Journal* (founded 1860) supported the longest-running series on local history: E. A. B. Barnard's 'Notes and Queries' (1906 to 1916) and 'Old Days in and around Evesham' (1920 to 1952). The Savoy Cinema stood opposite the Journal works.

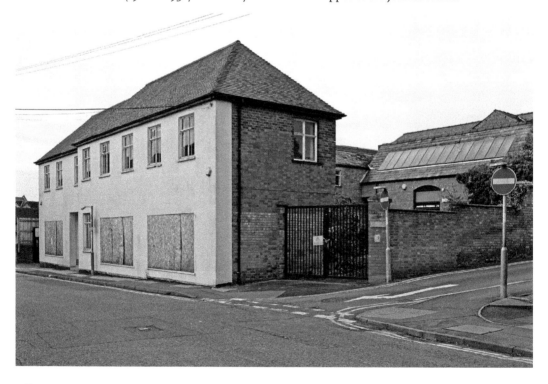

Rynal Cottages,
c. **1960 and 2015**
Twelfth-century Evesham was divided into four parts: Evesham, de Bertona, de nova burgo, and de Ruinhulla. There is debate about the precise location of these areas. Ruinhulla is thought to be the north side of Swan Lane plus the Rynal. Swan Lane is narrowest where it connects to the High Street, suggesting it was created by removing a single house there. The first houses on the Rynal, *c.* 1820, were these red-brick terraced houses with their Gothic-style flourishes.

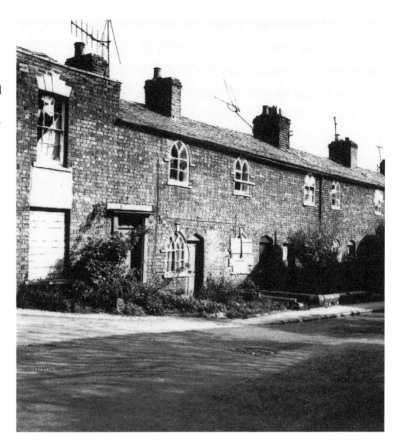

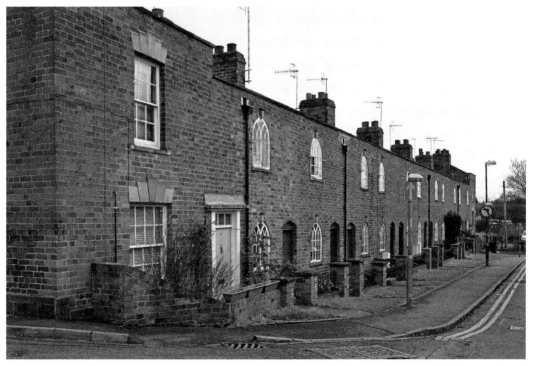

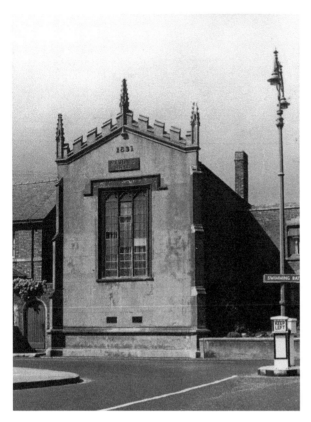

Masonic Hall, *c.* **1920 and 2015**
An infants' school, managed by the British and Foreign School Society, stood on this site from 1845. The building, purchased in 1914 by the Evesham Masonic Hall Co. Ltd, was used for both masonic ceremonies and non-masonic meetings (including Operatic Society rehearsals, bridge clubs, dance classes, and private parties). In 1940 the property was requisitioned to serve as a military canteen at a rental of £80 pa, being eventually released on 4 October 1946.

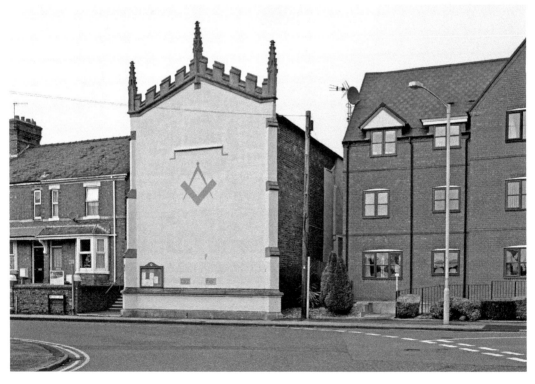

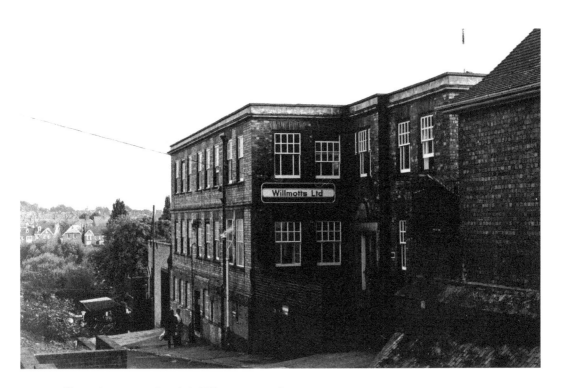

Willmott's Factory, Conduit Hill, _c._ 1950 and 2015

In 1882 James Willmott founded a case-making business in Birmingham. By 1904 he was looking for larger premises and moved to Evesham. In the Second World War the factory undertook munitions work. The North Works, previously occupied by a general engineering firm, was taken over in 1946. Willmott's enjoyed growing success from 1948 when the NHS provided spectacles with free cases. However, foreign competition led to the factory closing in the 1990s; in 2002 the site was developed as apartments.

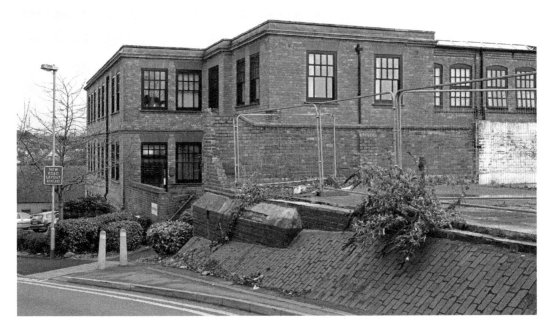

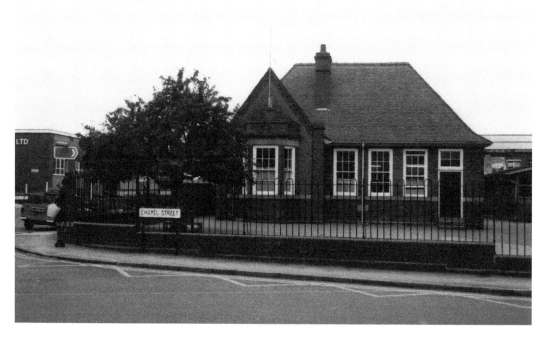

Swan Lane Infants' School, Chapel Lane, c. 1980 and 2015

Evesham Council School was officially opened in July 1910, and the Infant Department shortly afterwards in June 1913. Expansion in the 1970s saw the building of a new sports hall plus additional classrooms across the road (now Elim Pentecostal). In 1990 the school moved to new premises in the Rynal. The main school building became council offices, then stood derelict, and finally was bulldozed to create a car park in 2007. The infant school briefly survived as a registrar's office before demolition in 2012.

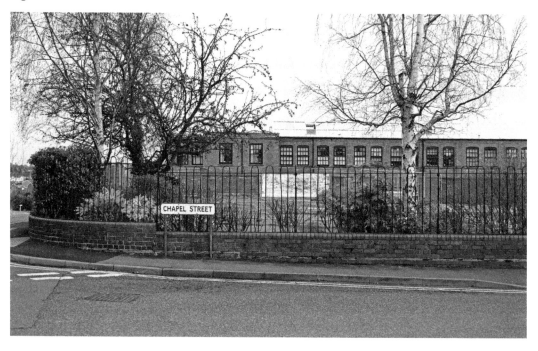

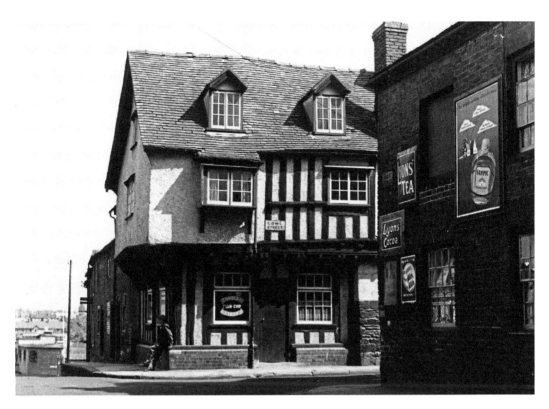

Shakespeare's Rest, Four Corners, *c.* 1950 and 2015

The junction between Mill Bank, Cowl Street, Oat Street and Chapel Lane was known as 'The Four Corners' (sometimes 'The Four Corners of Hell'). Two of the corners were demolished to create car parks, and one corner was remodelled to create a curving road. The surviving corner (between Oat Street and Mill Bank) is the site of 'Shakespeare's Rest'. Local legend says the playwright stopped here on his way to Worcester to collect the bishop's licence permitting him to marry.

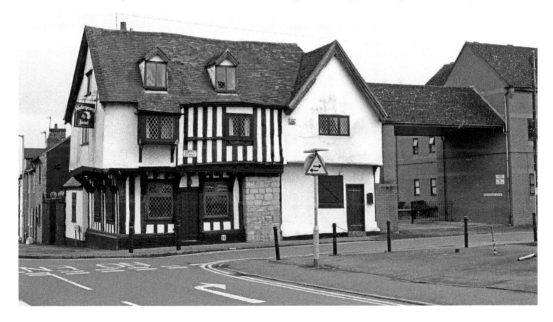

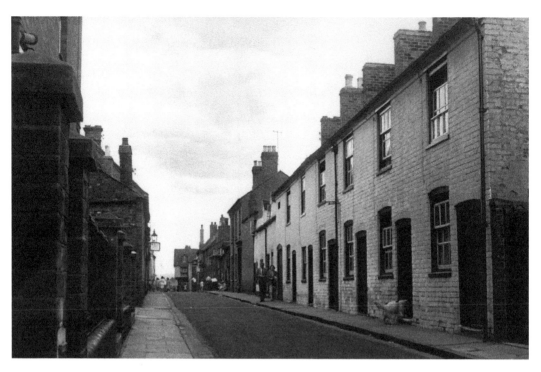

Oat Street Looking Towards Four Corners, *c.* 1950 and 2015
The name of this street, first mentioned in the fourteenth century, is a corruption of the original 'Ode' (or 'Wood'). Nightingale Court, near the corner with Cowl Street, was named after Mrs Amy Nightingale, headmistress of the Evesham Council School from 1919 to 1940, and in 1944 the first woman to be elected mayor of Evesham. The current Wallace House centre was opened in November 1969, and the new Library in Oat Street was opened in 1990 by Princess Margaret.

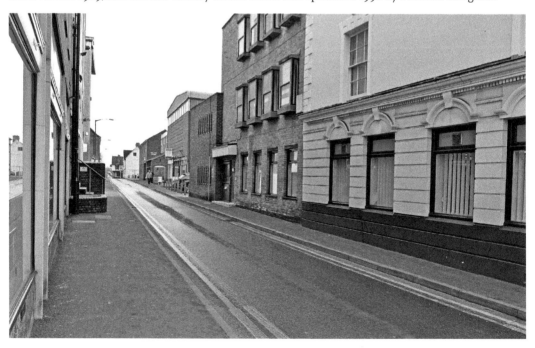

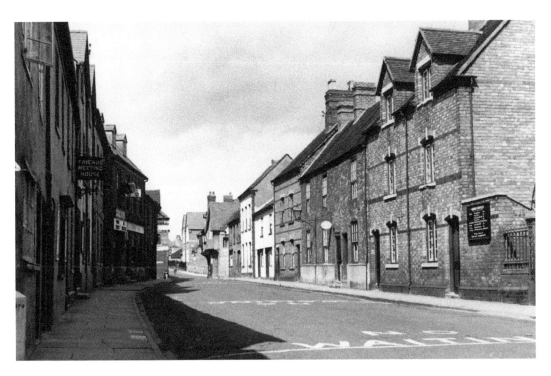

Cowl Street Looking Towards Four Corners, *c.* 1950 and 2015

The name of this street, first mentioned in the 1200s, is a Victorian corruption of the original 'Cole' (meaning 'coal'). Old courtyards led off this street, including Amphlitt's Court, Brotherton Court and Gould's Court. In 1655 the Quakers (the Religious Society of Friends) became active in Evesham and meetings were held in Edward Pitway's house on Waterside. Then in 1676 land in Cowl Street was bought and in 1677 the current Meeting House was built.

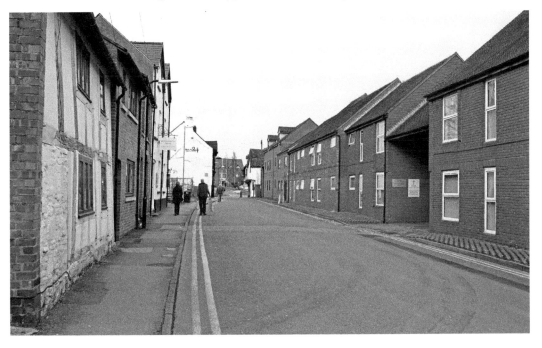

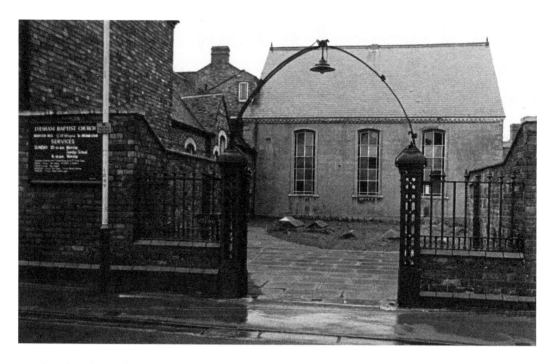

Baptist Chapel, Cowl Street, *c.* 1950 and 2015

Around 1670 the Baptists came to Evesham. Preaching services were initially held in private houses, but in 1704 a barn on the north side of Port Street was adapted for worship. In 1722 this was demolished and a new Meeting House built. In 1786 a site in Cowl Street was purchased and a new chapel was opened for worship in 1788 with twenty-one members. This chapel was demolished in 1979 and a new one built on the site.

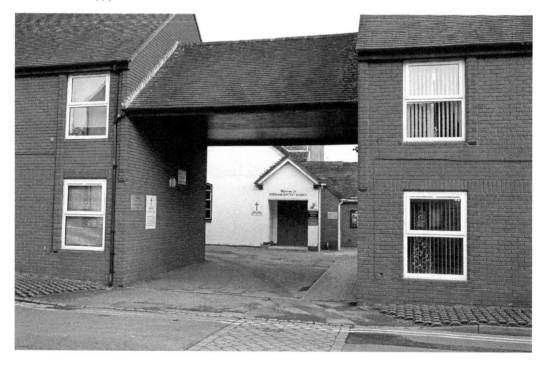

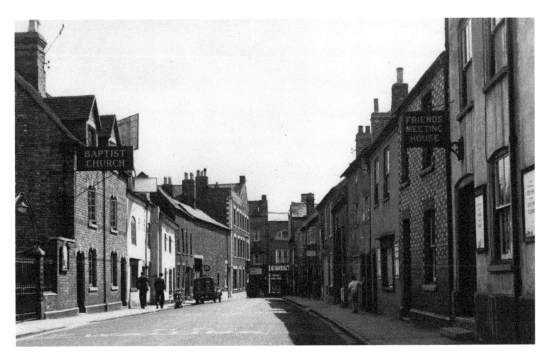

Cowl Street Looking Towards Bridge Street, *c.* 1950 and 2015

In 2002 the Wychavon Building Preservation Trust, with public funding and significant professional volunteer support, was instrumental in the restoration of a series of neglected historic buildings in Cowl Street. A former pet shop was taken back to its original half-timbered appearance, but only after a full archaeological survey which uncovered clay pipes, a headless figurine from the eighteenth century, a chunk of stone from Evesham's Abbey and a medieval cooking pot.

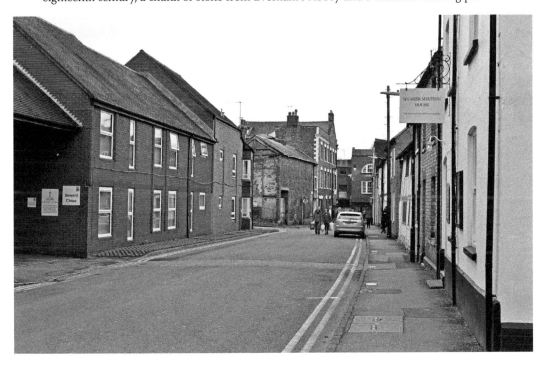

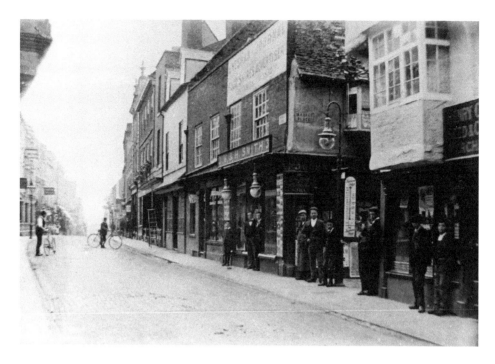

Journal Buildings, Upper Bridge Street, *c.* 1885 and 2016
The offices of W. H. Smith (publishers of the *Evesham Journal*, local almanacs and booklets) occupied the corner of Bridge Street which is now the stationers WHSmith (similar name, but no relation). This same building was, in the 1840s, the office of George May who in 1845 published his wonderful *A Descriptive History of the Town of Evesham, from the foundations of its Saxon Monastery with notices respecting the Ancient Deanery of its Vale* (more commonly called *History of Evesham*).

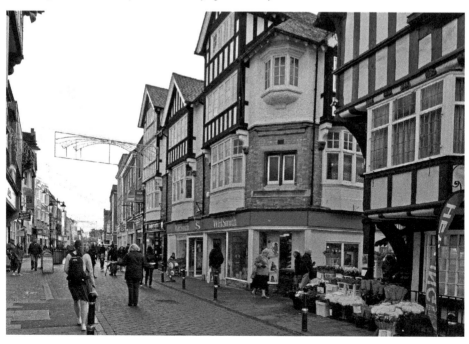

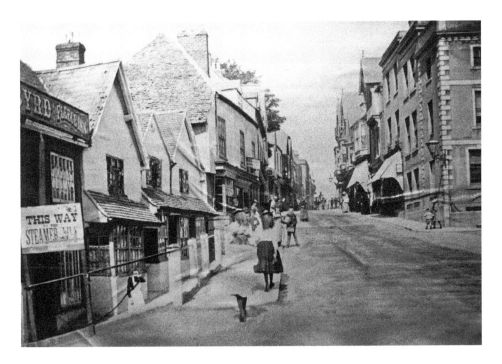

Lower Bridge Street, *c.* 1900 and 2015

Fleece Cottages, which sat below street level, were demolished in 1931 by the town council (they did own them). A great fight was waged to save the cottages, which was almost successful, by the Evesham Antiquarian Society (predecessor of the Historical Society) supported by SPAB and other learned bodies. An architect prepared plans to renovate the property (in poor condition) and convert it into one cottage with the old Fleece Inn transformed into public facilities in connection with Abbey Park.

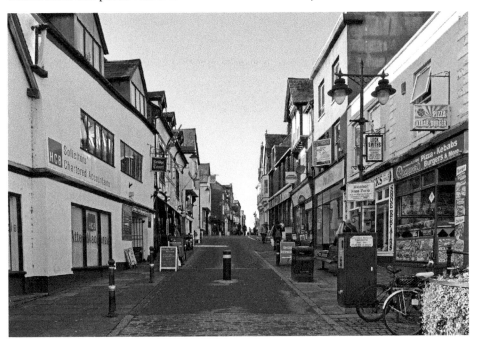

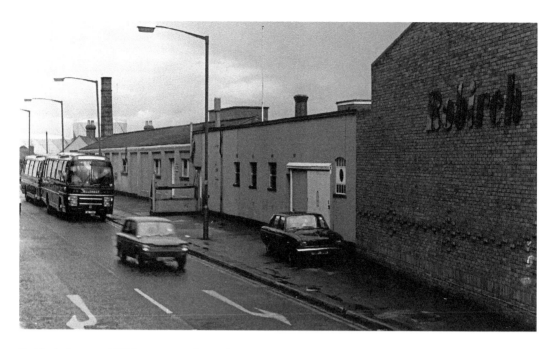

Robirch Factory, Mill Street, *c.* 1980 and 2015

A mill is mentioned in the Domesday Book, and Abbot Roger (1159 to 1160) built a mill by the bridge. During Tudor times there was a fulling mill and a shear-mill. In 1806 the fulling mill was fitted with new machinery to manufacture linseed oil and cake. These factories later became Avonvale Mills (flour), then Collins Bros, Robirch, and later still Stocks-Lovell. The factory chimney was dismantled in 1996, and over the following years the entire site developed as housing.

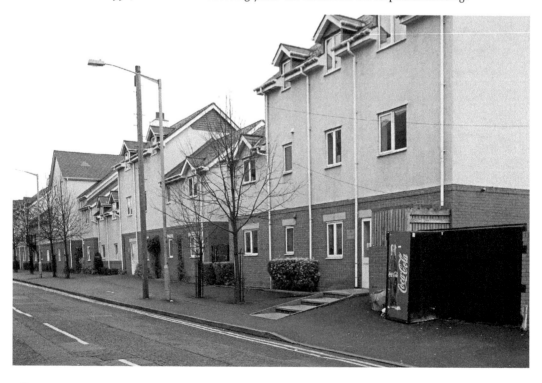

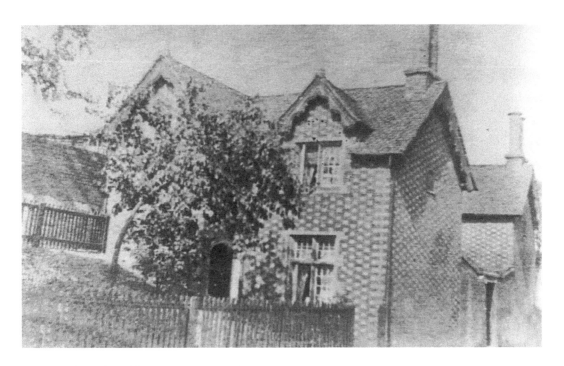

Rats' Castle, Mill Street, *c.* 1900 and 2015

The Rats' Castle cottages were demolished *c.* 1900 to improve the flow of traffic. Eva Beck in her 1952 autobiography *When I was a Little Girl* wrote of the nearby tannery (*c.* 1900): '... a terrifying place, guarded by fierce, chained dogs ... you passed between pits in which the leather was boiling and hardening ... various men appeared in leather aprons and prodded the hides in the pits with long poles. It was, I thought, a little like Hell as depicted in the Bible.'

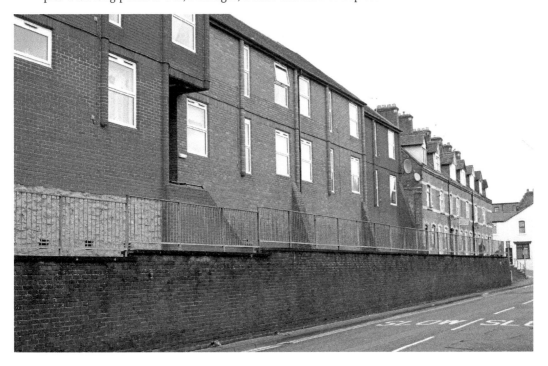

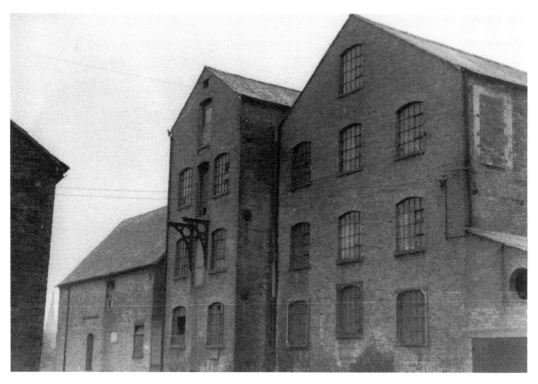

The Mill in Mill Lane, *c.* **1950 and 2015**

Since the Second World War light industry has steadily moved to the edges of the town: to Worcester Road, Briar Close, and the industrial estates off the Davies Road and bypass. The old industrial sites, such as Beaches (later Mandora) on Coopers Lane and the Stocks-Lovell factory on Mill Street, have been cleared and then redeveloped as housing.

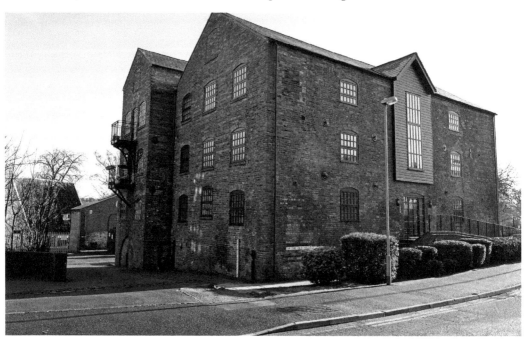

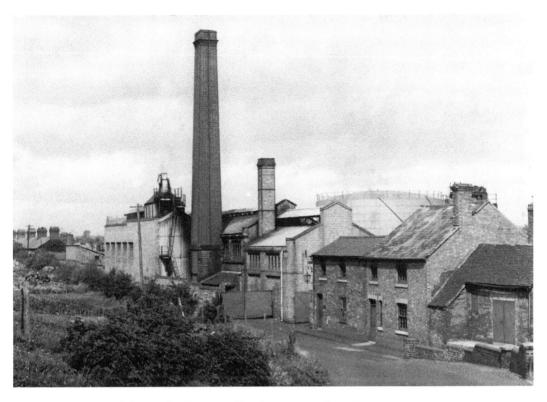

Gasometer and Gasworks, Common Road, *c.* 1950 and 2016

K. Gill Smith (1960) wrote that 'Evesham depended on gas for lighting, heat and power until 1925 ... The advent of electricity to Evesham was an important event in its history; indeed, it heralded a new era.' The site of the gasworks is currently vacant (permission has been granted for housing). Evesham United Football Club, 'the Robins', was founded in 1950 and moved to a ground down Common Road in 1968. This site was sold for housing in 2006; the estate is called 'Robins Corner'.

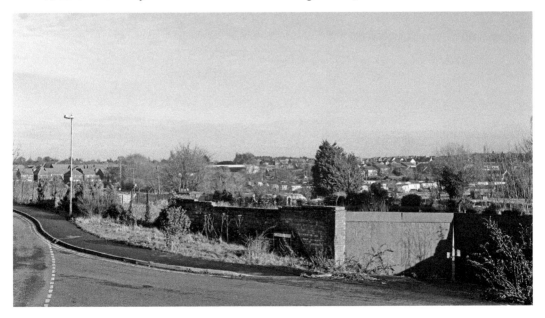

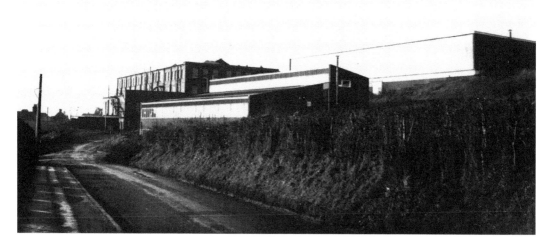

Willmott's, Conduit Hill Leading into Common Road, *c.* 1950 and 2015
In 1831 Thomas Nelson Foster established a bone mill here, next to his father's corn mill, to boil, grind, and sift vast quantities of bones for horticultural use. The mill was later incorporated into the factories on Mill Street. Common Road leads down to common land; that is, a tract of open land used in common by the inhabitants of the town.

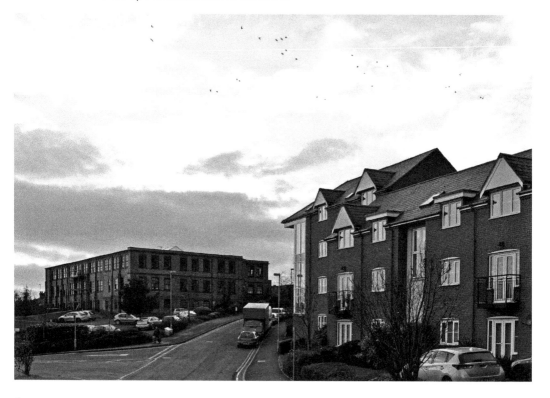

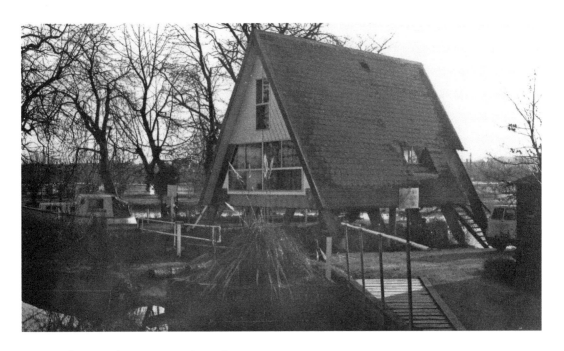

Lock Keeper's House, *c.* 1980 and 2015

The A-framed lock keepers house was built in 1972 by the Lower Avon Navigation Trust. The floods of 1998 and 2007 caused significant damage to the house, and it was feared it might have to be demolished, but happily was saved by being raised higher above the waters. The town has long suffered from flooding: the New Century Flood of 1900 saw the river rise by over 15 feet (other exceptional floods occurred in 1924, 1932, 1947 and 1968).

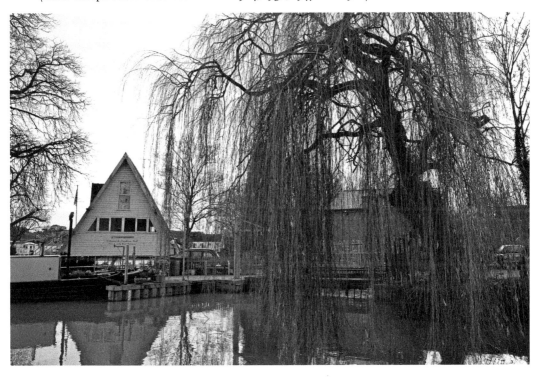

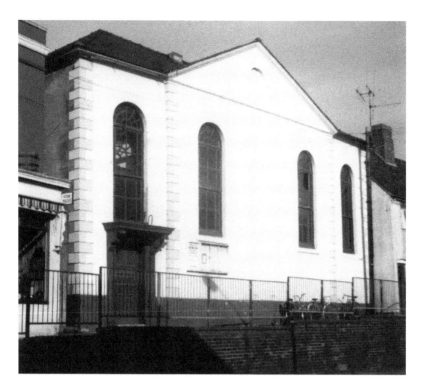

Mill Street Meeting Room, *c.* 1960 and 2015

The land was bought *c.* 1789 from farmer John Roper who returned the purchase price of 100 guineas to help fund the building of a new Baptist chapel. Apparently when the Baptists moved from Bengeworth there was a split in the community: some went to the chapel in Cowl Street and some to Mill Street. The two congregations were united in 1857 and this building converted into lecture rooms. *Littlebury's Directory* records the Plymouth Brethren meeting here in 1873.

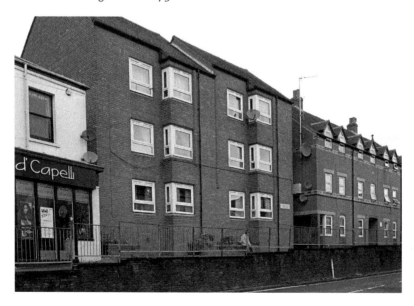

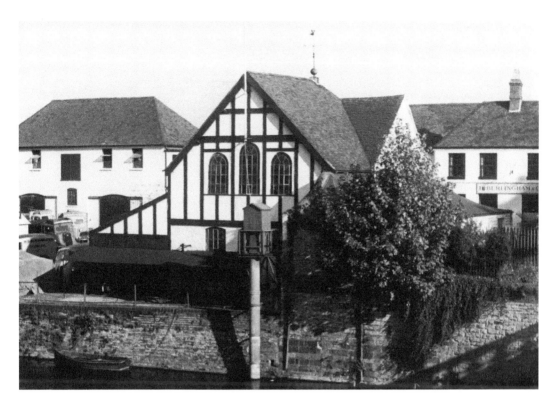

Burlingham's Yard, c. 1950 and 2015

This area, sold in 1995 for housing, is now named 'Mortimers Quay' after Roger de Mortimer who slew Simon de Montfort at the Battle of Evesham. The name of nearby 'Castle Street' recalls a fortification built in the twelfth century by William de Beauchamp; from here his men launched raiding parties against the abbey. For these crimes he was excommunicated by the abbot, and the castle was seized, razed and the site consecrated as a cemetery to prevent future rebuilding.

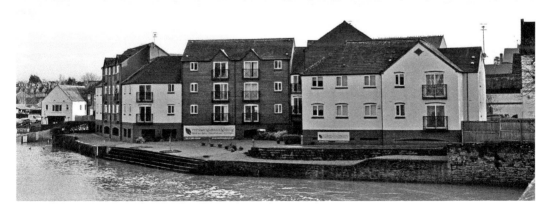

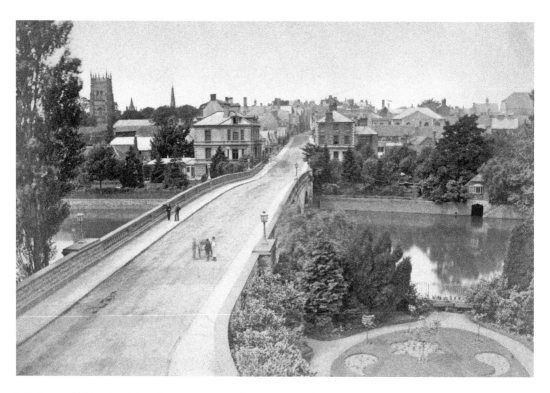

Workman Bridge Looking from Bengeworth, *c.* 1880 and 2015

The earliest mention of a bridge is *c.* 1155. In June 1644 Charles I left Evesham and broke the bridge. The townspeople immediately repaired it. When the king returned, a few days later, he levied a fine, took the mayor and certain aldermen as prisoners, and ordered the town to provide 1,000 pairs of boots. On his departure he again broke the bridge. In 1845 George May described the narrow eight-arched bridge as an 'architectural abortion'; it was replaced in 1856 by the three-arched Workman Bridge.

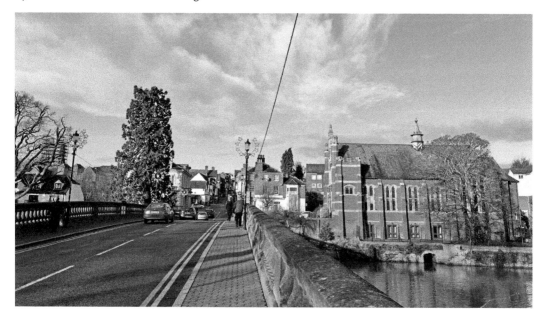

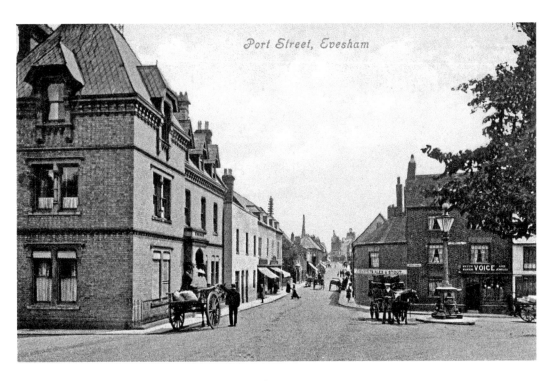

Port Street, Evesham

Bridge House, No. 1 Port Street, 1890 and 2015
This intriguing building, in French Renaissance style, has a varied history. It was built in 1907 as the residence of Dr Harry. In 1926 it became the Hotel Bonear. From 1927 the site was operated by the Ministry of Works, and in 1969 was taken over by builder merchants Burlinghams. The site was sold in 1995 and the main house became shops, office and flats.

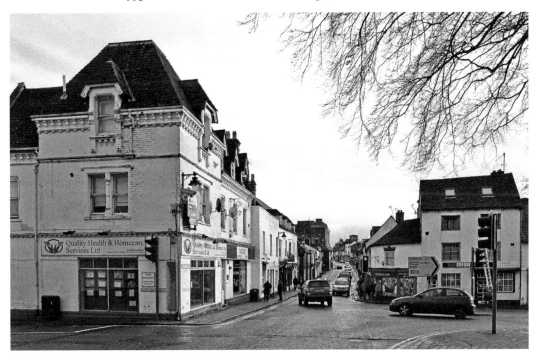

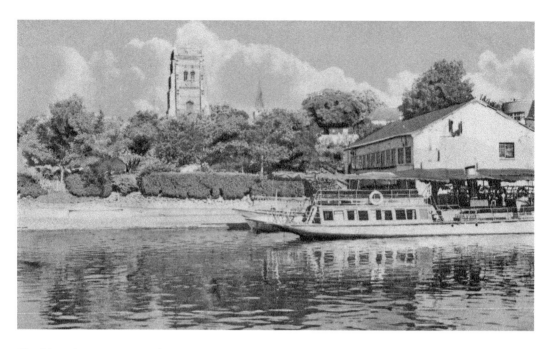

The River Avon, *c.* 1920 and 2015

The corner of land tucked between Lower Bridge Street and Abbey Park was a series of yards and wharfs for the Fleece Inn. It is rumoured that contraband tobacco, rum and lace were smuggled into the town from here in the eighteenth century. The wharfs later became Sammy Groves Tea Rooms and later, after a devastating fire, the Marine Ballroom (Mr Arthur Tolley, the owner, lived in Avonbridge House). In the 1990s the site was developed into housing called Monks Walk.

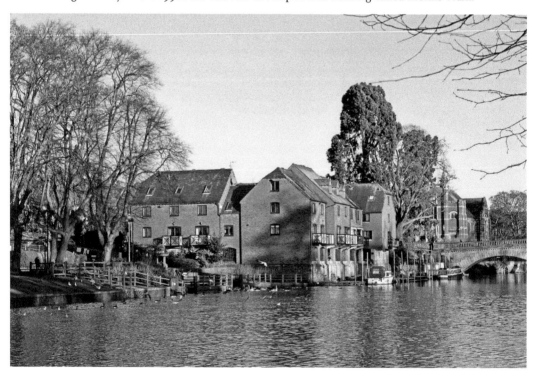

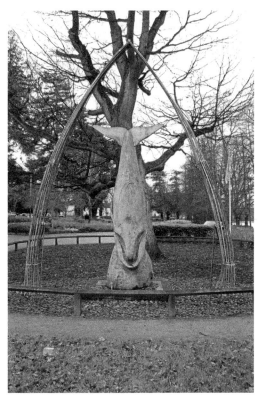

Whale Jawbone, *c.* 1930 and 2015

The Jawbones Arch (from a Bowhead whale) was originally received by Dr Beale Cooper from his friend Mr Stanton who assisted in an extended Arctic whaling expedition aboard the ship *Andrew Marvel* in 1819. In 1906 the bones were donated to the town and erected in the Workman Gardens. Growing fragile over time, in 2012 the bones were removed and, in 2013, replaced by a metal arch and a beautiful whale carving by Tom Harvey.

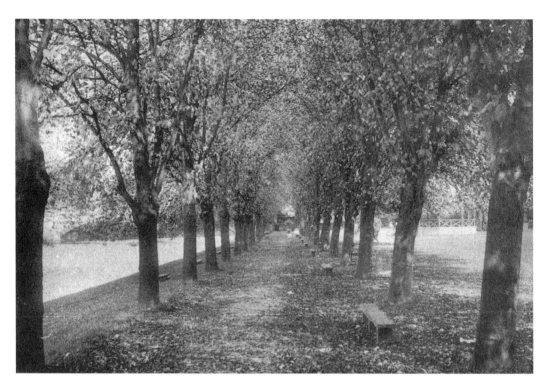

The Avenue, Workman Gardens, *c.* 1900 and 2015

The Workman Gardens (sometimes called the Workman Pleasure Grounds) were named in honour of Henry Workman who served as mayor for five consecutive years and oversaw the replacement of the old Bengeworth Bridge. The gardens were opened in May 1864 and in June 1864 were the setting for the Evesham flower show and regatta. This site was previously occupied by a range of warehouses and river wharfs.

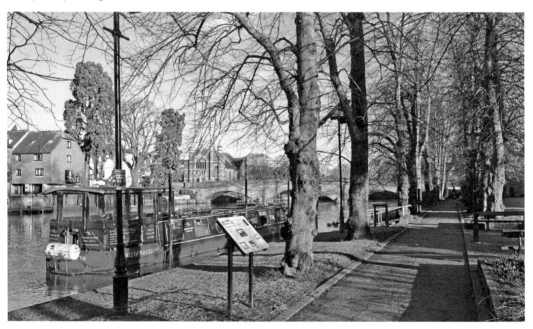

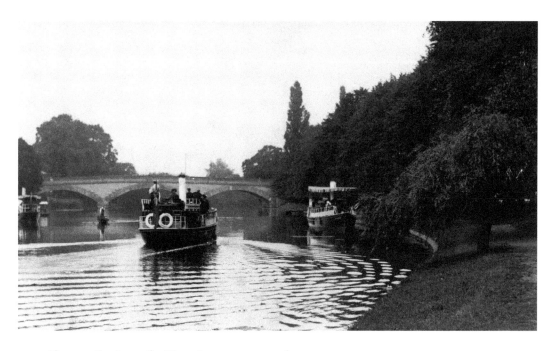

Pleasure Boats on the River Avon, *c.* 1930 and 2015

Many people have enjoyed 'messing about on the river'. Charles Byrd (and later his sons) operated the steam boat, *The Princess Royal*, then from 1880 *The Golden Fleece*, then *The Lily* (rebuilt in 1907 as *The Lilybyrd*), adding in 1919 the steam launch *Diamond Queen*. Sammy Grove ran steamers from Avon Bridge Tea Rooms; his fleet variously included *King George*, *Saucy Sue* and *Gaiety* (on the Avon from 1928 to 1989). An annual river festival now celebrates boating and the Avon.

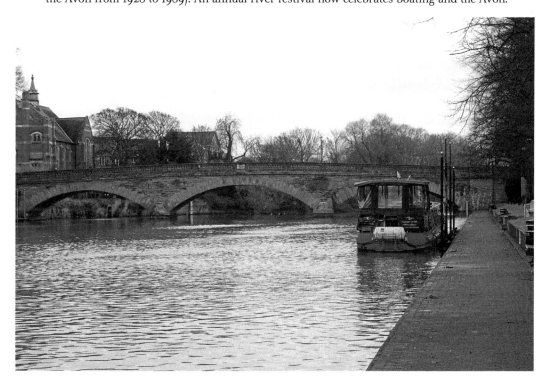

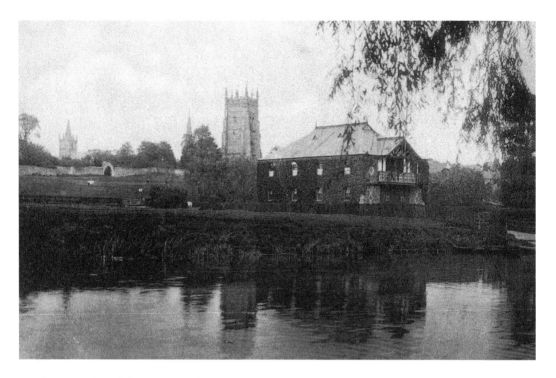

Evesham Rowing Club, *c.* 1900 and 2015

The club was formed in 1863 with Edward Charles Rudge elected as President (the Rudge family have long been benefactors) and with boats and equipment housed in timber boathouses leased from The Fleece. In 1892/93 the club moved to its present site and a brick clubhouse was constructed, extended in 1908 and also in 2005/06.The first Regatta in 1864 was between the clubs from Evesham and Tewkesbury. This event has since grown to become 'the Henley of the Midlands'.

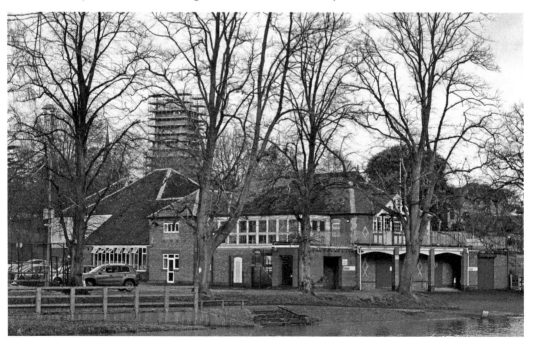

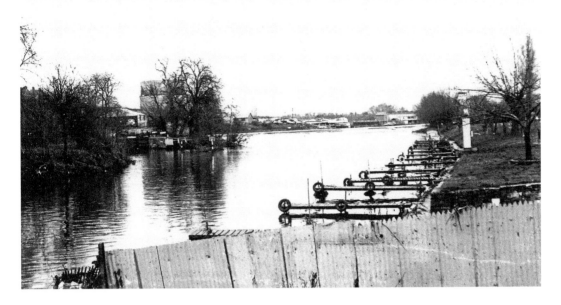

The Weir, *c.* 1950 and 2015
A sign by the lock proclaims: 'Empowered by a charter granted to him by King Charles the First on the 9 March 1635, Wm Sandys of Fladbury made this river Avon navigable, but in the early 20th century the navigation became derelict. Twelve years of dedicated work by The Lower Avon Navigation Trust subsequently restored the 28½ miles between Evesham and the confluence with the River Severn at Tewkesbury. The navigation was re-opened on Sunday the 10th of June 1962 by Mrs C.D. Barwell.'

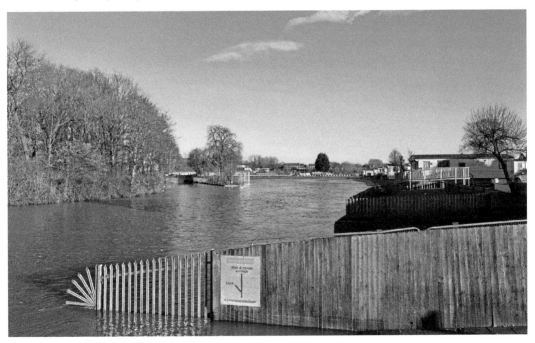

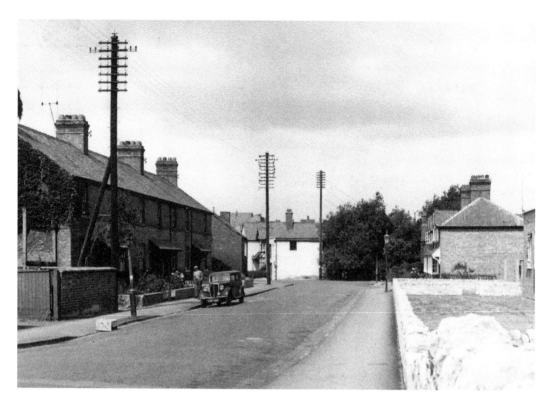

Lower Leys, *c.* 1935 and 2015

The name 'The Leys' probably denotes open untilled land used as pasture. The Leys is divided by Burford Road into the Lower Leys and the Upper Leys. In 1885 the wharf at the western end of the Leys was known as Spragg's Wharf. This is now the only freely accessible public wharf in Evesham. In 2010 the tax office here was closed down and the site developed as flats and offices.

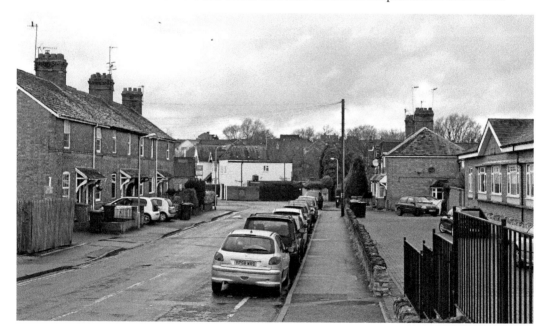

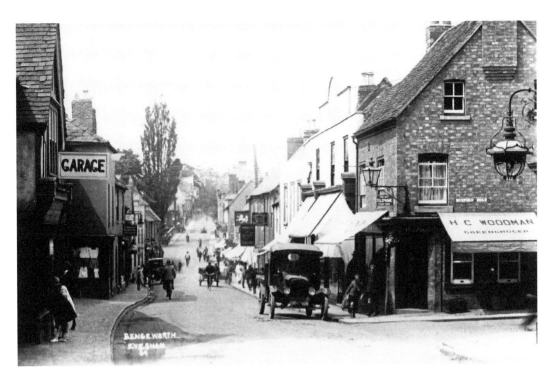

Regal Cinema, Port Street, *c.* 1910 and 2015

The Regal was opened on 10 October 1932 and provided films and entertainment until it closed down in 2003. After fundraising and restoration, it reopened on 21 January 2012. The town's other cinema, the Clifton in High Street, started life in 1923 as The Scala Theatre, and became the Clifton in 1938 when the façade and interior were remodelled. The Clifton Cinema closed in 1980; the building briefly became a bingo hall, and in 2007 was converted into a café.

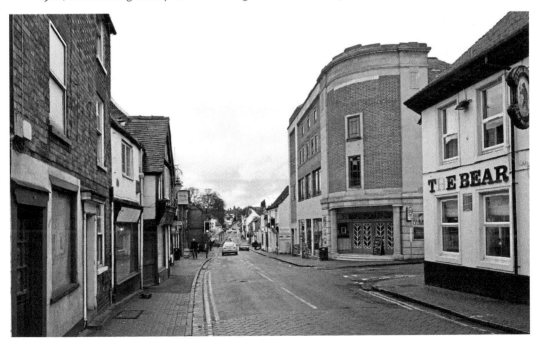

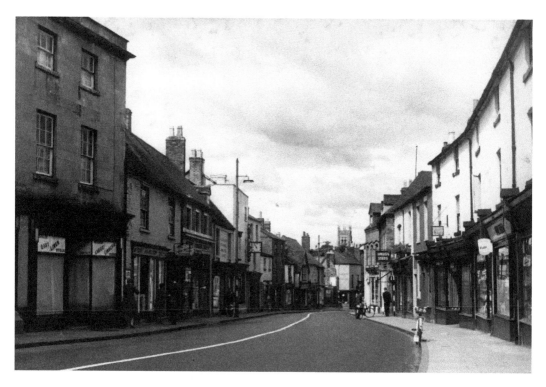

Port Street Looking Towards the Bell Tower, *c.* 1950 and 2015
Tindal (1794) wrote that 'Bengeworth consists of little more than a single street, called Port-street.' Some forty years later George May (1834) wrote in praise of Port Street: 'This street – in the neatness of its houses, the condition of its roads and flagways [pavements], together with the refreshing accompaniment of a pellucid stream murmuring on either side – now yields not, in the cheerful cleanliness of its appearance, to any other portion of the town.'

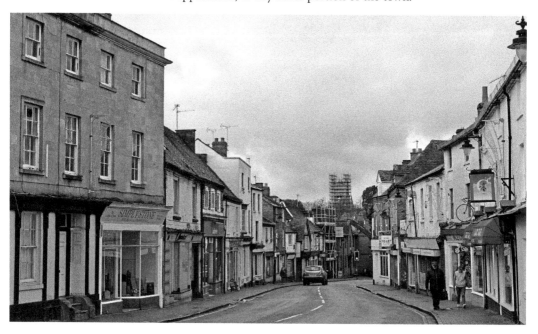

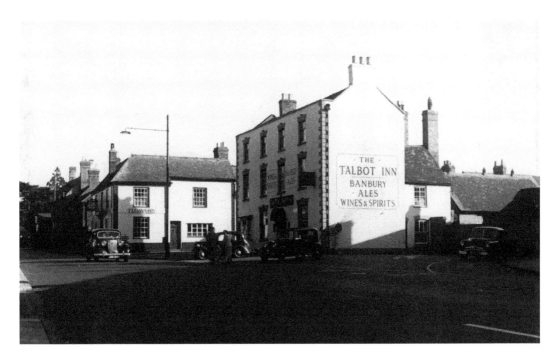

Talbot Inn, Port Street, 1930 and 2015

The Talbot Inn sits on the site of Bengeworth's ancient village green. The inn, first mentioned in 1573 as the Bell Inn, had its own running water supply rising from a spring in the cellar (flowing in a piped channel under Port Street and Castle Street down to the river). The Talbot closed as an inn in 2013 and has since been converted into flats.

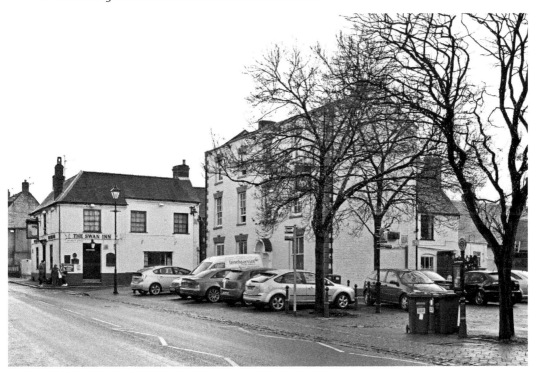

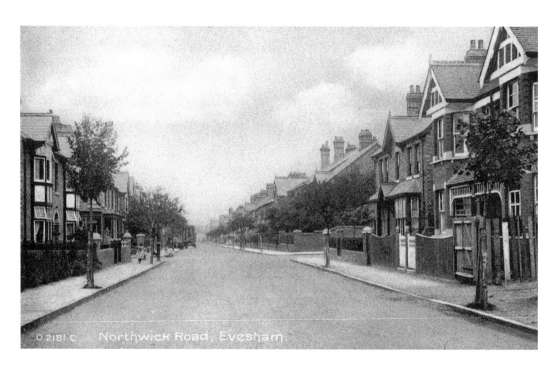

Northwick Road, *c.* 1920 and 2015

In 1900 to 1915 new housing estates were developed in Bengeworth. Northwick Road was named after one of the principal landowners in the area, Sir John Rushout, Bart. of Northwick Park, Blockley (later created Baron Northwick). The nearby Burford Road is named after one of his other estates – Burford in Shropshire in the Tenbury area. The names of Kings Road and Coronation Street celebrate the accession of Edward VII (in 1901; crowned in 1902).

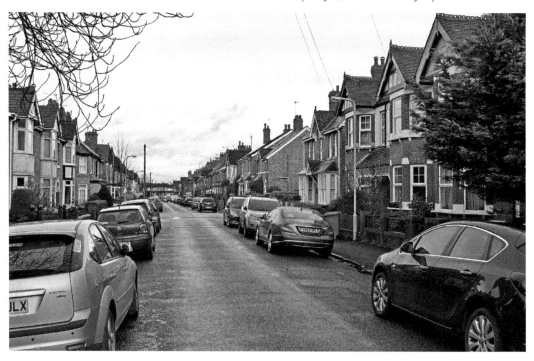

St Peter's Church, *c.* 1910 and 2015

The foundation stone was laid on 24 October 1871 by Lord Northwick on land he provided, and the church consecrated by the Bishop of Worcester on 4 September 1872. A peal of six bells was cast specially by William Blews & Sons using metal from the five bells from the old church. These bells, rarely rung since 1992, have a special listing as the last complete ring of bells cast by Blews still in their original condition.

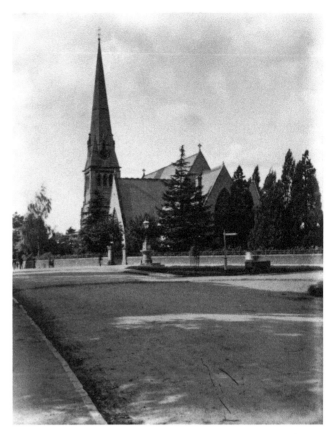

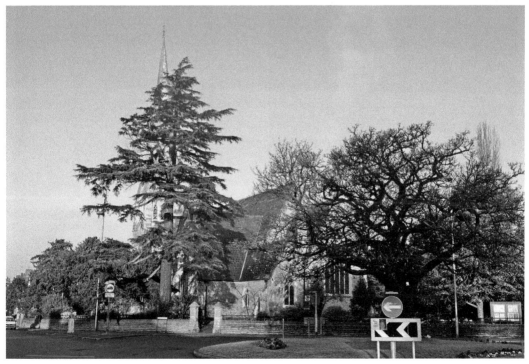

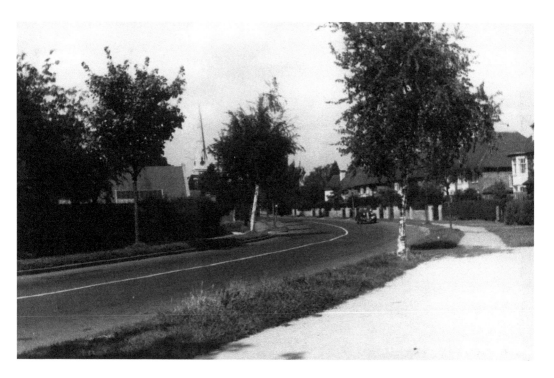

Broadway Road, c. 1935 and 2016

The Broadway Road in Evesham becomes, with pleasing symmetry, the Evesham Road in Broadway. This, the old London Road, probably follows the line of an old saltway. The site now occupied by Bengeworth Cemetery was from at least 1827 known as Amen Corner; the name probably comes from marking the site during the rogation-tide ceremony of beating the parish bounds. This corner became the location of a toll gate when the Broadway Road became a turnpike road.

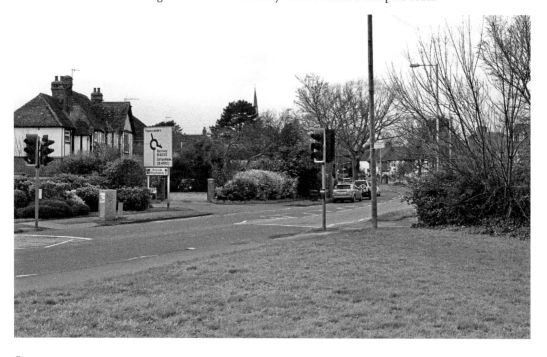

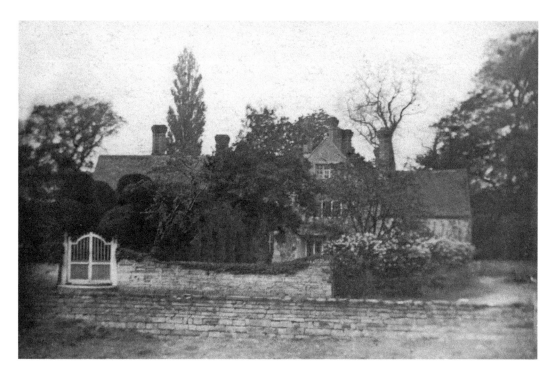

Bengeworth Vicarage, c. 1890 and 2015

Bengeworth Vicarage, at No. 49 Broadway Road, was built in 1866 in the Gothic style. It was later demolished and the site developed as Cedarwood Gardens (named from the large cedars in the garden). The vicarage then moved to No. 1 Broadway Road, previously a private residence and doctor's surgery, before that was sold in 2012 to become a private house again. The church hall was designed by Mr Dicks (of Evesham) and was officially opened in 1923 by the Right Hon. the Earl of Coventry.

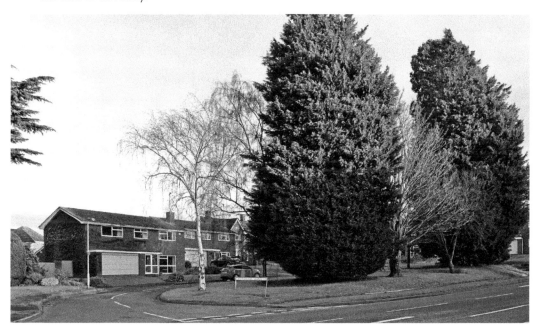

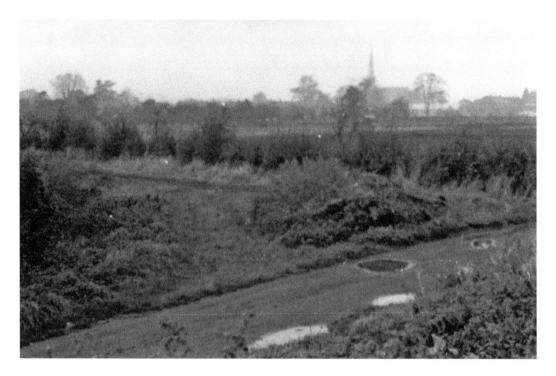

Durcott Lane, *c.* 1950 and 2015

Up until the 1830s market gardening in Bengeworth was mainly concentrated at Owletts End and Durcott Lane. Kenneth Gill Smith (1960) described '... the typical Vale of Evesham grower, past and present ... They were skilled men and, in many families, gardening was carried on generation after generation. These men were independent and outspoken. Self-employed (and, as they extended, increasingly employing labour themselves) and knowledgeable in their work, they were not inclined to "kow-tow" to anyone.'

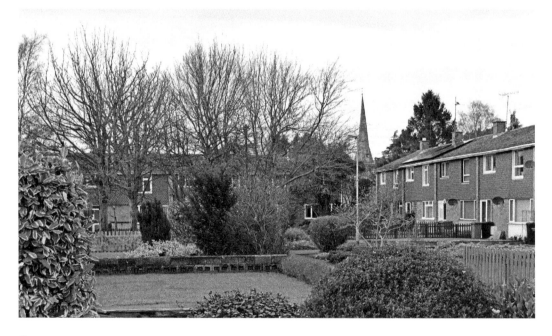

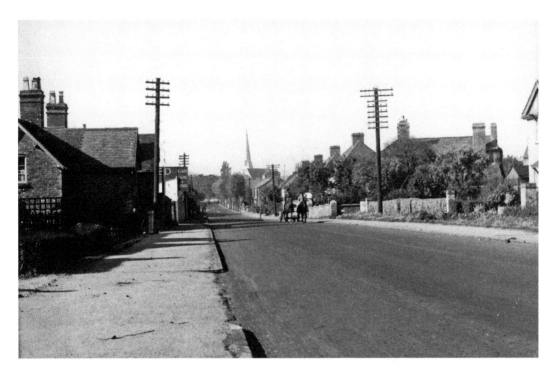

Elm Road, *c.* 1950 and 2015

This road is named after the ancient elm that stood at the top of the hill; the tree was removed in 1953 to make way for road-widening works. In the early 1800s George Day established the brickyards that stretched between Elm Road and Badsey Lane, and built the house originally called 'The One Elm'. He was an enterprising Bengeworth man whose rapid rise to success was, sadly, matched by an equally rapid decline.

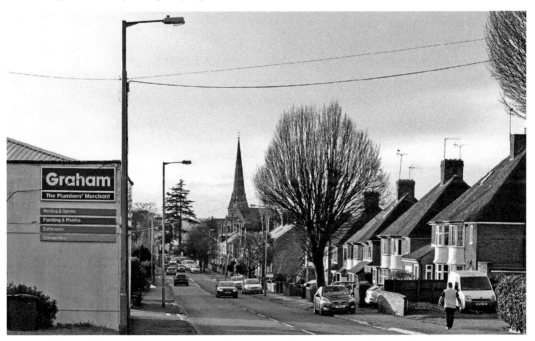

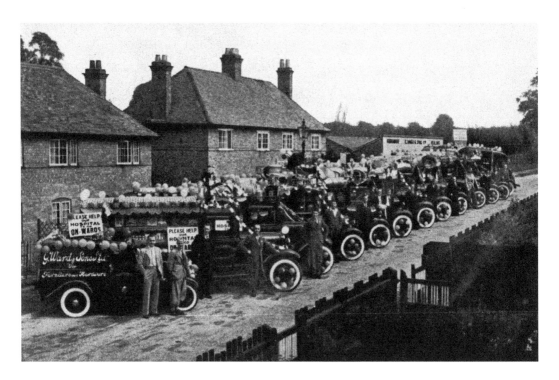

Badsey Lane, 1939 and 2016

George Ward started his 'pavement retail service' in 1908 with a horse and cart based in Kings Road. The business soon moved to Badsey Lane and, after his death, was continued by his three sons, George, Clem, and Harry, who all lived in the lane. In the 1930s their fleet of silver-painted mobile shops toured the vale and Cotswolds selling everything from pins to paraffin (particularly useful during rationing) and hiring china, cutlery and glasses for parties.

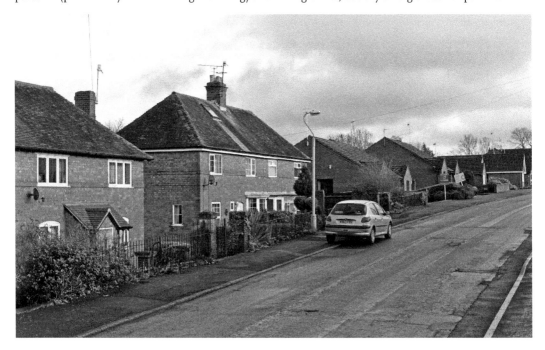

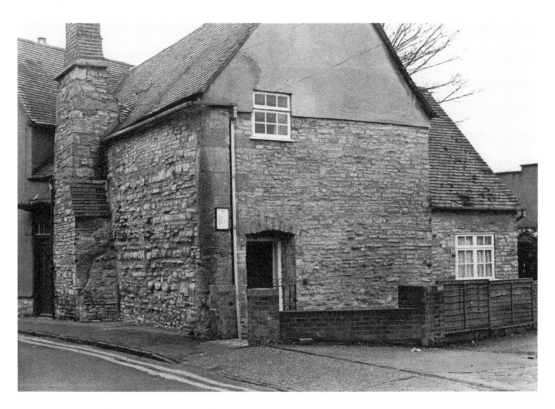

Bengeworth Manor, *c.* 1950 and 2015

Bengeworth Manor, home of the prior of Evesham Abbey, is the oldest building in the parish with doorways and mouldings from the fourteenth century. In 1600 Lewis Bayly, rector of All Saints, was instrumental in Evesham obtaining its first royal charter in 1604. A second charter, granted in 1605, incorporated Bengeworth within the borough for 'the better rule, government and improvement' of the town following 'many controversies, dissensions, offences, riots and other violations and disturbances of our peace'. It seems that Bengeworth was then rather unruly.

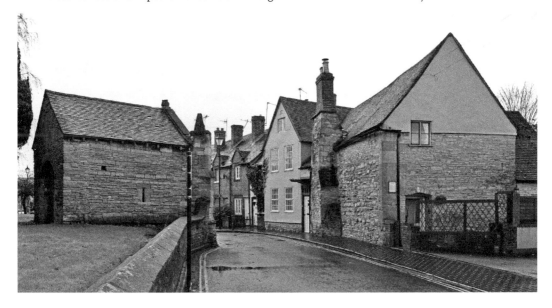

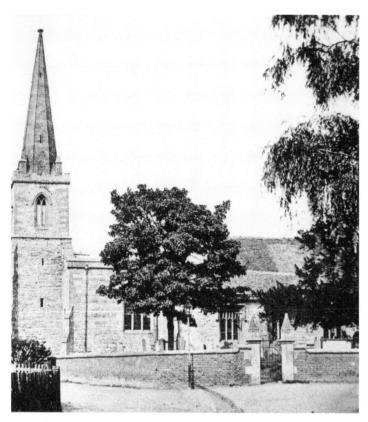

Old Bengeworth Church, *c.* **1870 and 2015**
Local legend says the old church was built using stones from the old castle (from which Castle Street is named). This church was dynamited in 1872 once the new St Peter's was erected. Perhaps they shared the opinion of William Tindal (1794): 'a large, irregular, and plain, but ancient edifice; ornamented with few monuments of note'. Revd Shawcross (1927) lamented this 'great misfortune to Bengeworth, and not only great but irreparable ... the outward and visible standing proof of its antiquity'.

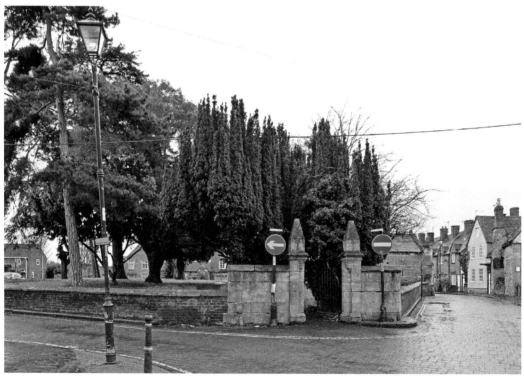

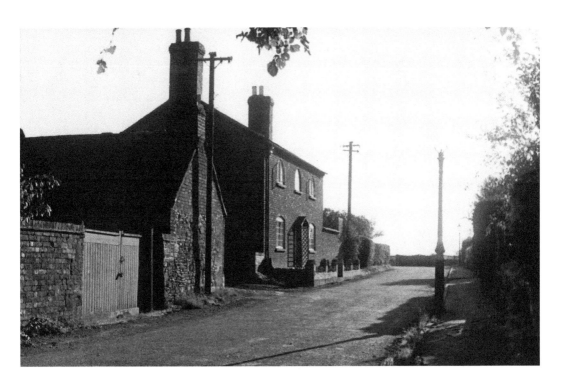

Owletts End, *c.* 1950 and 2015

In Anglo-Saxon the place-name element 'End' denotes an extremity or remote locality. For Bengeworth it marks the end of the village; indeed, until 1903 the name 'Owletts End' referred to this general area rather than a specific lane. Bengeworth once supported a thriving nail-making industry. William Golden (1912) remembered that passing up The Leys with 'the cheerful glow and tinkle of the nail-shops, seemed like entering Elysium'. The last nail-maker, Elizabeth Williams, died in 1919.

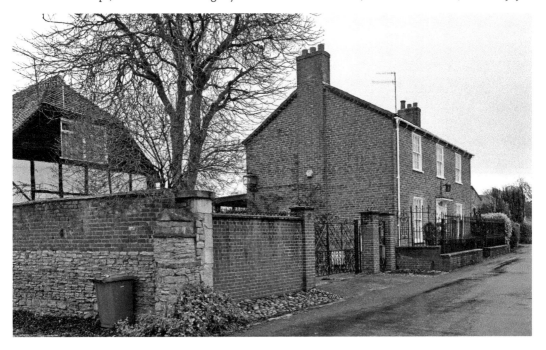

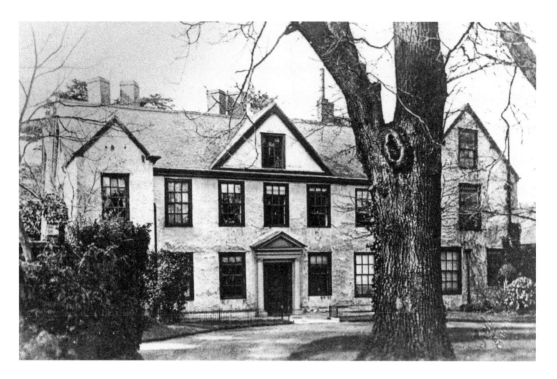

Mansion House, *c.* 1900 and 2015

In 1539 Thomas Watson bought 100 acres of abbey land in Bengeworth and built the Mansion House. The lane alongside became known as Watson's Lane. In 1771 the Revd Thomas Beale became vicar and rented the Mansion House. Upon his death in 1805 the property was taken over by his only surviving nephew, Dr Beale Cooper, who nearly doubled the size of the house. The lane was now known as Beale Cooper's Lane (pronounced in the local Asum dialect as 'Bell Cupper') – later shortened to Cooper's Lane.

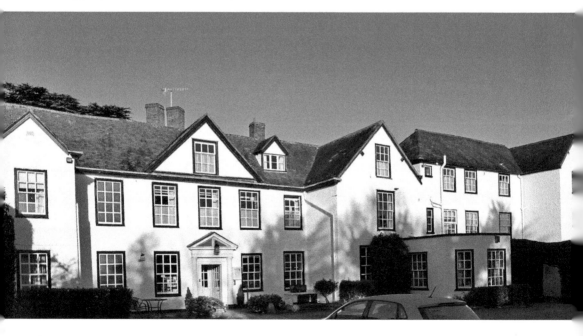

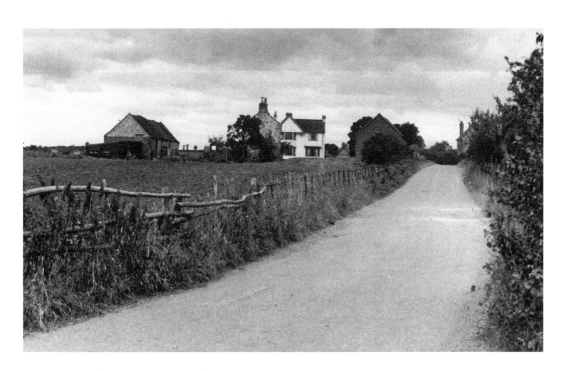

Four Pools Farm, *c*. 1950 and 2015

The name of the farm derives from four large pools on this site. B. G. Cox (1972) wrote, 'Bengeworth in 1872 consisted of little more than Waterside, Port Street, The Leys and Church Street with a few isolated houses on the outskirts of the Parish, Crab Farm, Four Pools Farm and Bunkers Hill Farm.' In 1872 the residences of the principal residents were the vicarage, Lansdowne, Hollymount (now known as Hill Crest), The Elm (now called Prospect House), and the Mansion House in Cooper's Lane.

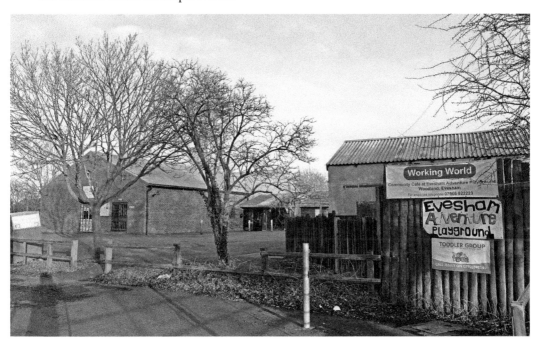

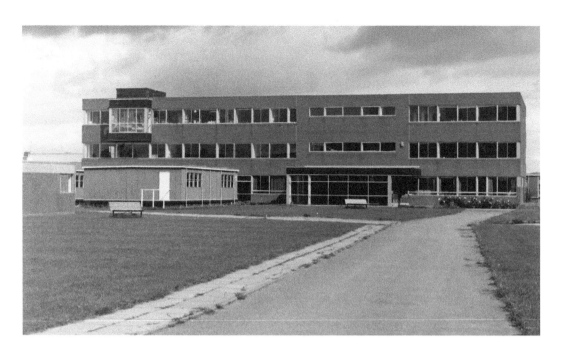

Evesham College, (now South Worcestershire College, Evesham Campus) Davies Road, c. 1975 and 2015

Evesham College was constructed as part of an impressive programme of public building which also saw the construction of Evesham High School (1951/52, extended 1974) now called De Montfort School, Simon de Montfort Middle School (now merged with the high school), St Egwin's Middle School (1975/76), and the Vale of Evesham School (1969). The college sits at the end of Davies Road, named after a former town clerk who helped promote the construction of the Evesham bypass.

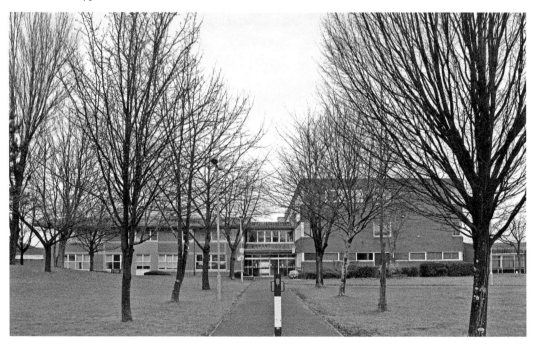

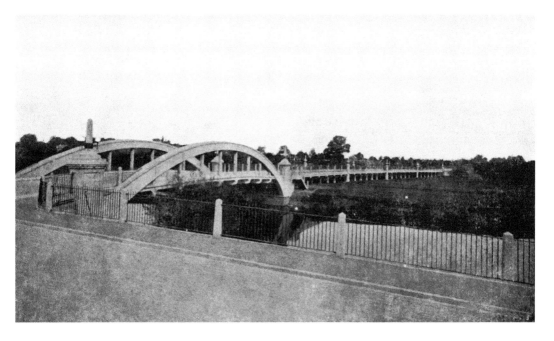

The New Bridge or Abbey Bridge, 1928 and 2015

Motor traffic increased significantly after the First World War. Congestion in Bridge Street became unbearable and a new bridge over the Avon was thought a necessity. A steel and ferro-concrete bridge was built with a viaduct (Abbey Road) connecting it to Merstow Green, previously a cul-de-sac. The bridge was opened in 1928 by the Hon. Wilfrid Ashley, then Minister of Transport. Significant flooding, especially in 2007, weakened the bridge leading to its replacement in 2014 (the new 'New Bridge').

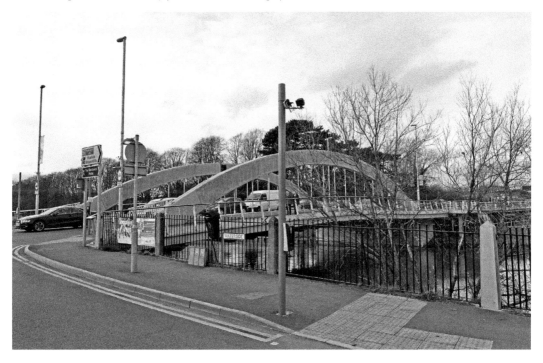

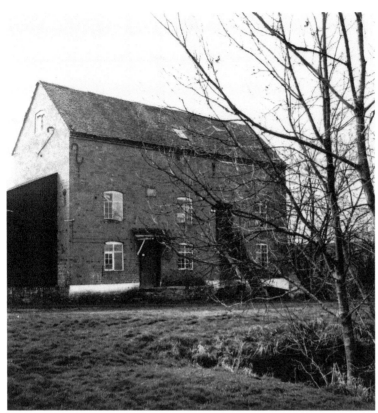

Hampton Mill,
c. 1950 and 2015
This impressive four-storey building, now a private home, was erected in 1830 to replace an earlier structure destroyed by fire. In 1906 a turbine replaced the waterwheel. The mill was still operating in 1956. The mill sits on the River Isbourne (known locally as Hampton Brook) which is said to be the only river in England flowing from south to north. The riverside walk from the Hampton Ferry to the Isbourne was known *c.* 1900 as Lover's Walk.

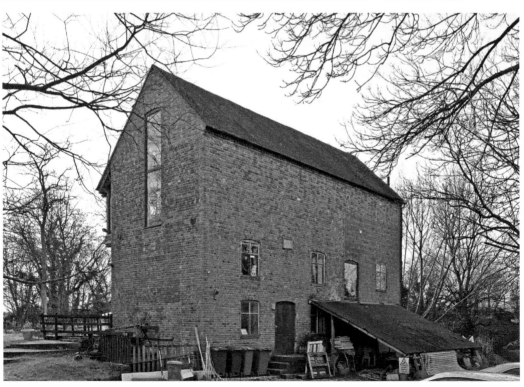

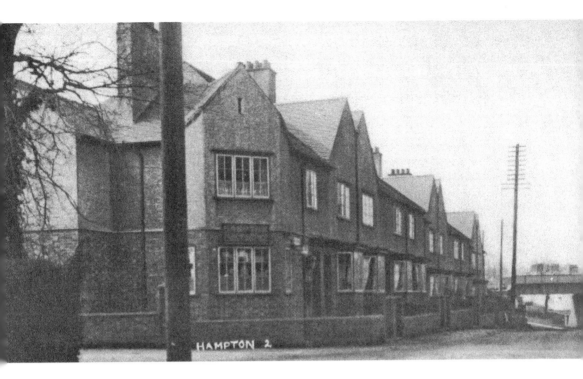

Hampton, with Railway Bridge, *c.* 1910 and 2015

In 1933 the parish of Great and Little Hampton was incorporated within the borough of Evesham and was represented on the town council by an alderman and three councillors. The Ashchurch to Barnt Green line, part of the Midland Railway network, ran through the centre of Hampton. The station, although in Hampton, was labelled 'Bengeworth' to distinguish it from all the other stations named Hampton.

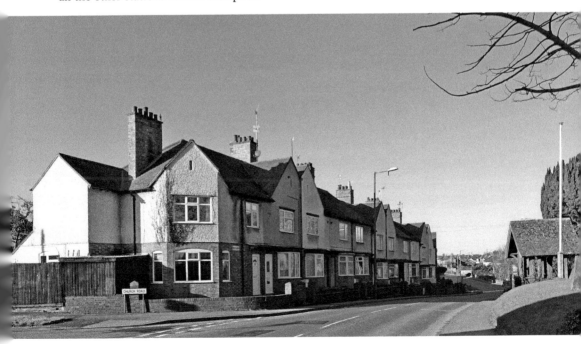

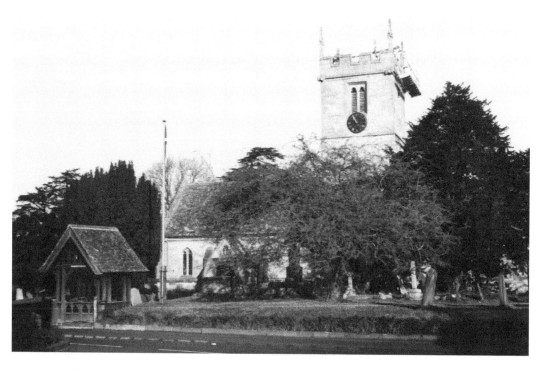

St Andrews' Church, *c.* 1965 and 2015

This church, dating from the twelfth century but largely rebuilt *c.* 1400, stands upon a gentle knoll overlooking the river and abbey demesne land. Near the south door rests the chest tomb of yeoman farmer John Martin (1637–1714). His will gave land and property to provide assistance to the poor, for education, and to support the local clergy. The bequeathed land in Little Hampton was sold in the 1980s and 1990s for housing and development (in and around the appropriately named Charity Crescent).

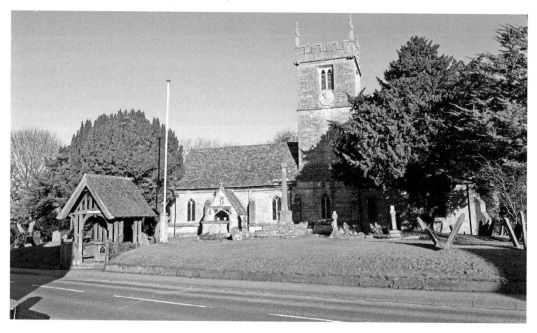

Acknowledgements

I would like to thank everyone, past and present, who has helped, supported or donated to the Vale of Evesham Historical Society (VEHS). Their collections, held at the Almonry, are a local history treasure trove. I would like to thank the *Evesham Journal* for permission to use selected images. I would also like to express especial thanks to John Kyte, Mike and Wendy Wagstaff, Chris Grove, Patrick and Mary Brotherton, and Neville Cole for their help in preparing this book.